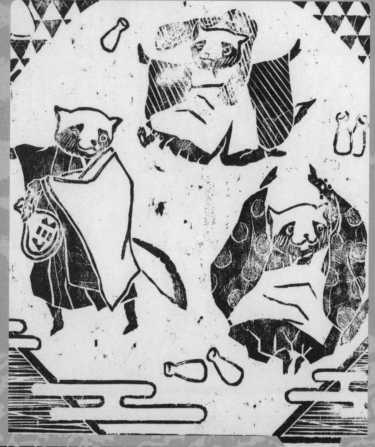

SIGNAL.05

SIGNAL:05

Signal:05 edited by Alec Dunn & Josh MacPhee
© 2016 PM Press
Individual copyright retained by the respective writers, artists, and designers.

ISBN: 978-1-62963-156-1
LCCN: 2016930976

PM Press, PO Box 23912, Oakland, CA 94623
www.pmpress.org
www.signal.org

Design: Alec Dunn & Josh MacPhee/AntumbraDesign.org

Cover image: Joaquín Arostegui, Estudio, woodblock printed at the Club de Grabado de Montevideo, 1967. Frontispiece: outside image is from the Club de Grabado de Montevideo Almanac; inset graphic by A3BC. Background image on this spread is a collection of political 7" record covers from 1960s/70s Italy. Image on following page spread: Alexander Apsit's Internationale Pyramid, Soviet Union, 1918.

Printed in the United States.

Thanks to everyone who worked on this issue. Special thanks to Silvia Federici, Monica Johnson, Malav Kanuga, Keisuke Narita, Andrew Thompson, Interference Archive, Book Thug Nation, , and everyone at PM Press for their continuing support of this project.

SIGNAL
is an idea in motion.

ИНТЕРНАЦИОНАЛ.

The production of art and culture does not happen in a vacuum; it is not a neutral process. We don't ask the question of whether art should be instrumentalized toward political goals; the economic and social conditions we exist under attempt to marshal all material culture toward the maintenance of the way things are. Yet we also know that cultural production can also challenge capitalism, statecraft, patriarchy, and all the systems used to produce disparity. With *Signal*, we aspire to understand the complex ways that socially engaged cultural production affects us, our communities, our struggles, and our globe.

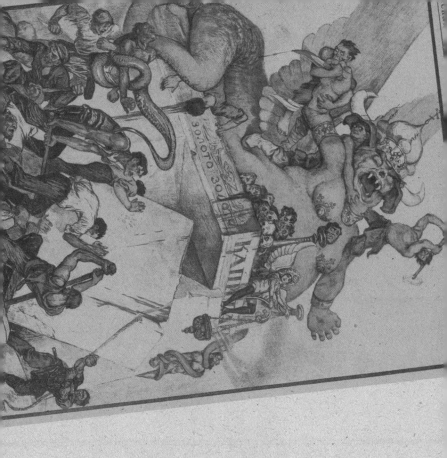

We welcome the submission of writing and visual cultural production for future issues. We are particularly interested in looking at the intersection of art and politics internationally, and assessments of how this intersection has functioned at various historical and geographical moments.

Signal can be reached at: editors@s1gnal.org

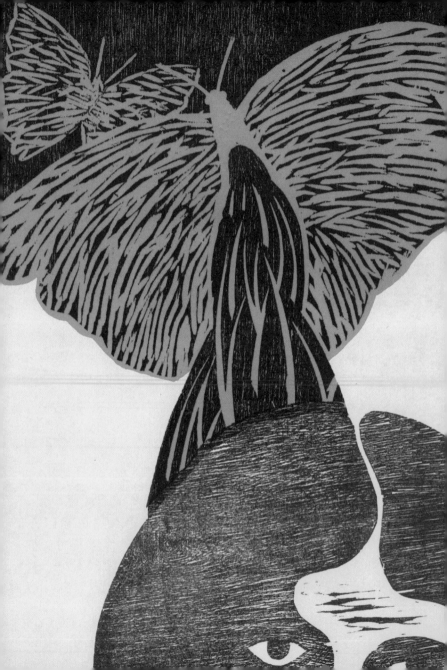

I dreamt I was going far away from here,
the sea was choppy,
waves black and white,
a dead wolf on the beach,
a log surfing,
flames in open seas.

Was there ever a city called Montevideo?
—Christina Peri Rossi[1]

I n Montevideo I searched for nothing in particular in mounds of flea market junk: acrid leather goods, discount bras, and little bottles of designer perfume. Then I started noticing recurring pages from small publications from the 1960s and '70s buried there. Moldering calendar months covered in poetry of utopian imagination, and poetry of exile, different from year to year. As loose pages of frayed paper they blended in easily, hidden beneath other lost things come apart. Commanding printed images of caged birds, flowers growing from layered barbed wire, a dove reaching with fingers instead of feathers, men meeting, looking suspicious and paranoid, all shared small references to a Club de Grabado de Montevideo (CGM). Together these fragments tell a history in woodcuts and screenprints of collectivized art-making, international socialist solidarity, and a radical vision for shared cultural production.

The following is the product of interviews with some of the surviving members of the CGM, as well as my own translations of archival interviews and of the texts contained within the prints themselves.

<div align="center">

* * *

1953–68

</div>

The CGM printmaking collective existed between 1953 and 1993 in Uruguay's capital city. In August of 1953 a building in the center of Montevideo—the former studio of the painter Pedro Blanes Viale—was turned into club headquarters. Over time it became a public workshop for making woodcuts and linocuts. A forum for communal printmaking and a space for teaching and exhibiting work, the CGM was an independent local platform for participating in political, and aesthetic, conversations internationally.

Cultura Independiente

We affirm that in order to advance towards our first stage, which we see as the massive diffusion of printmaking as art form, we can't remain at the margins of the political social and cultural processes of our country (Uruguay), of Latin America, or of the world.

On the contrary, it is our duty to assume a combative, and fearless defense of civil liberties, to act in defense of a social justice that permits a just redistribution of resources and a respect for human rights.
—Club de Grabado de Montevideo *(1967 Almanac)*

In 1949 the twenty-six-year-old artist Leonilda González arrived in Paris to study in the studios of the cubist painters André Lothe and Fernand Léger (also a Communist Party member). In April of 1953 she attended the socialist Continental Congress of Culture, organized by Pablo Neruda in Santiago de Chile. González connected with other Uruguayan artists while abroad, and came in contact with collective initiatives developing elsewhere in Latin America, such as the Taller de Gráfica Popular from Mexico (founded in 1937), the Club de Grabado de Porto Alegre (founded in 1950) and the Club de Gravura de Bagé (founded in 1951), both from Brazil. Upon her return to Montevideo, González, together with Aída Rodríguez and Nicolas Loureirro, rented a space initially known as "El Taller" (The

Hugo Alíes, cover design for the *1968 Almanac*, woodcut and offset lithography.

almanaque 1968

TALLER CLUB DE GRABADO DE MONTEVIDEO

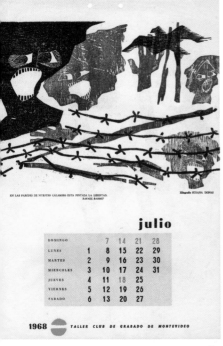

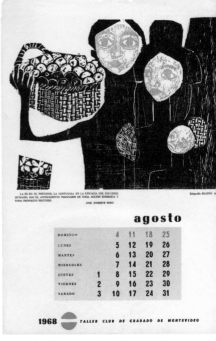

EN LAS PAREDES DE NUESTRO CALABOZO ESTA PINTADA LA LIBERTAD.
RAFAEL BARRET

Xilografía SUSANA DONAS

LA FE EN EL PORVENIR, LA CONFIANZA EN LA EFICACIA DEL ESFUERZO
HUMANO, SON EL ANTECEDENTE NECESARIO DE TODA ACCIÓN ENÉRGICA Y
TODO PROPÓSITO FECUNDO.
JOSÉ ENRIQUE RODÓ

Xilografía GLADYS A

julio

	DOMINGO		7	14	21	28
	LUNES	1	8	15	22	29
	MARTES	2	9	16	23	30
	MIERCOLES	3	10	17	24	31
	JUEVES	4	11	18	25	
	VIERNES	5	12	19	26	
	SABADO	6	13	20	27	

1968 TALLER CLUB DE GRABADO DE MONTEVIDEO

agosto

	DOMINGO		4	11	18	25
	LUNES		5	12	19	26
	MARTES		6	13	20	27
	MIERCOLES		7	14	21	28
	JUEVES	1	8	15	22	29
	VIERNES	2	9	16	23	30
	SABADO	3	10	17	24	31

1968 TALLER CLUB DE GRABADO DE MONTEVIDEO

From left: Susana Donas, woodcut, July/*1968 Almanac*; Gladys Afamado, woodcut, August/*1968 Almanac*; Tina

Workshop) where the CGM evolved into being. At the time, most young Uruguayan artists with the financial means to do so would go to Europe in order to be recognized at home. It was a great shift to establish a vibrant shared place for learning in Montevideo itself, with other collectives in Latin America as points of reference.

In an attempt to break from capitalist conditions for cultural production, the CGM functioned on a membership basis; *socios* paid small dues in exchange for monthly prints, and access to the workshop. A national history of social clubs in Uruguay meant a framework for reimagining a means of art-making already existed in cinema and theater clubs funded by member dues. As a consequence, the print club grew fast, and participating artists quickly became accountable to fellow members, rather than the wider market. There were 50 members to begin, 1,500 in 1964, and 3,500 by 1973. With each member paying one peso a month, the model wasn't just

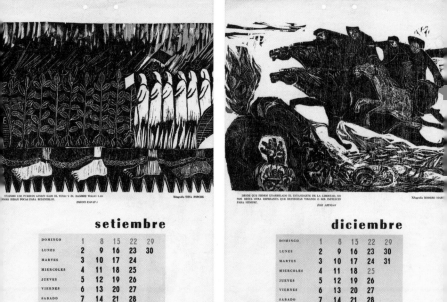

Borche, woodcut, September/*1968 Almanac*; Homero
Martinez, woodcut, December/*1968 Almanac*.

financially pragmatic but also political, representative of a concerted
effort to create a *cultura independiente*, a popular narrative that could
exist parallel to state-approved cultural production.[2]

Influenced by the cultural criticism of British anarchist
Herbert Read, the collective saw an educational role for artists, and
sought to reduce the barriers preventing proletariat workers from
being consumers of art.[3] González sought to have prints be "as read-
ily available as potatoes."[4] Aiming to do away with the idea of art as
precious and develop a direct line between artists and nonartists, the
CGM made their process accessible. In 1955 the Club de Grabado
threw their first of several street exhibitions on Plaza Libertad. They
held workshops in their Montevideo studio, the prints they pro-
duced were inexpensive, and CGM artists traveled with exhibitions
through rural Uruguay, making portable prints available throughout
the (very small) country.

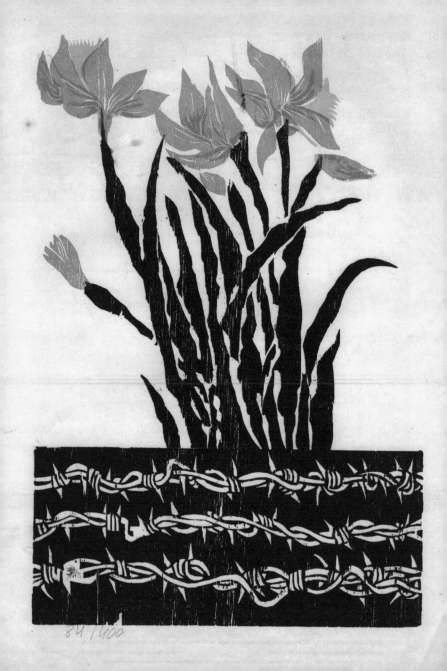
84/400

Many of the images focus on populist scenes—people carrying baskets of fruit, a group of workers, women resting on a balcony with their hair in rollers. Most layer sharp contrasting color with radical prose and poetry, taken from the works of South American writers and poets. But beyond a shared aesthetic, CGM members were bound to one another in their use of printmaking as a public and socialist practice—working to create places to make art outside of preordained state or university patronage.

In addition to monthly pieces, the club began producing an annual almanac in 1966. These were collaborative calendars, with artists taking on different months, together weaving their works chosen around a theme, their connective tissue being a shared reflection on the political climate of the year. Together they act as a people's history for the years in which they were made.

* * *

1968–73

"I shall say only one sentence. The revolutionary ideal of the nineteenth century was internationalist; in the twentieth century it became enclosed in nationalism and the only internationalists left are the artists."
—Herbert Read, Cultural Congress in Havana, Cuba, 1968[5]

By 1969 signs were starting to show of the vicious Cold War violence that would spread throughout the Southern Cone in the years to come. In 1968 Uruguayan president Jorge Pacheco Areco declared a national state of emergency in order to quell labor disputes and censor the press. The Montevideo-based socialist urban guerrilla group Los Tupamaros responded by escalating their militancy, kidnapping a bank manager and a former FBI agent, as well as establishing a people's prison to deal with what they saw as state impunity. Political dissidents were being imprisoned in mass numbers by the government, suspected insurgents were disappearing,

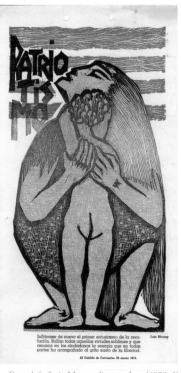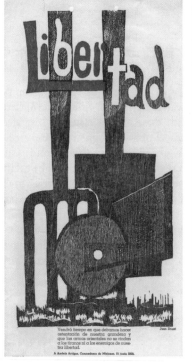

From left: Luis Mazzey, linocut, June/*1970 Almanac*; Juan Douat, woodcut, July/*1970 Almanac*; Tina Borche, woodcut, September/*1970 Almanac*.

and the Uruguayan government began fiercely using torture against civilians during interrogations.

The CGM's quotidian imagery from this period includes jarring frames of chained limbs and censored mouths. Within this political climate the CGM space was raided by police on multiple occasions. But the collective succeeded in keeping strong alliances with socialist art collectives internationally and maintaining their mobility. They traveled to international gatherings in South America and sent members annually to Eastern Europe to participate in Intergrafik, an international gathering of printmakers in East Germany. Intergrafik brought together artists from across continents for a series of workshops and traveling exhibitions, uniting work from otherwise disparate collectives in a multilingual socialist practice.

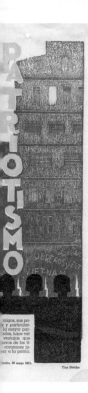

Tina Bottche

* * *

1974-85

The National School of Fine Arts was closed soon after the 1973 military coup established a dictatorship in Uruguay. By that point the CGM already had its roots planted as a shared environment for learning and art-making. With the art school closed, artists were drawn to CGM workshops as an avenue to further their practice.

Their formal status as a stand-in art school didn't serve to protect the collective from state scrutiny. After the publication of the *1974 Almanac* Rimer Cardillo recalls spending a night in prison together with Leonilda González, Octavio de San Martín, Rita Bialer, and Gladys Afamado. That year, the almanac was covered in protest songs. According to Óscar Ferrando, who was then a student of the club, their arrest took place immediately as the almanacs were printed in December 1973. The almanacs themselves were seized by the state and the group was held overnight. The militant voice of the club necessarily folded in on itself after that, many members were forced into exile, and all were censored.

Deeper into the dictatorship, between 1976 and 1979 several key members—including Leonilda González and Rimer Cardillo—left Uruguay. The club maintained itself as a straightforward school, with artists such as Nelbia Romero, Óscar Ferrando, Héctor Contte, Ana Salcovsky, and Alicia Asconeguy offering classes in screenprinting, metal etching, woodcut, and linocut. The group carried on with younger printmakers maintaining the name, but the political edge of the project had been dulled in order to survive military rule.

The ability to gather together in groups was limited and hushed the artists' meetings. Fear and self-imposed censorship created distance from the public, and the quality of the art changed. A closely guarded culture proved corrosive to creating a public art practice. Whereas in 1974 they produced four thousand prints a month, by 1979 the monthly print runs had dropped below one thousand.[6]

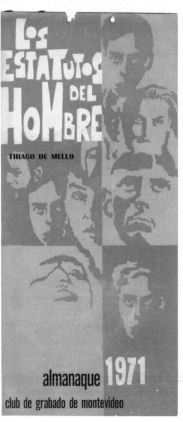
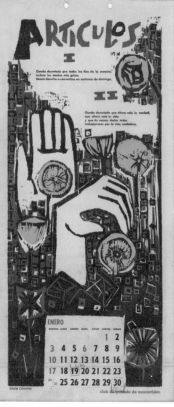
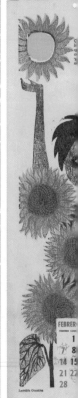

From left: Nelba Romero, woodcut, cover image of the *1971 Almanac*; Gloria Carrerou, woodcut, January/*1971 Almanac*; Leonilda González, woodcut, February/*1971 Almanac*; Rita Bialer, woodcut, June/*1971 Almanac*; Hilda Ferreira, woodcut, December/*1971 Almanac*.

* * *

1985–93

In 1985 the military dictatorship gave way to a democratically elected presidency. The *1985 Almanac* was made with the theme of return, piecing the poetry of Uruguayans in exile—famed poets and young children together:

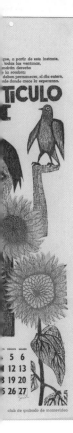

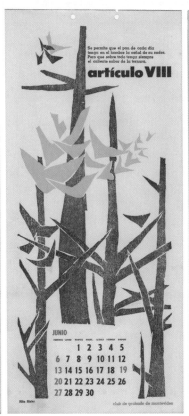

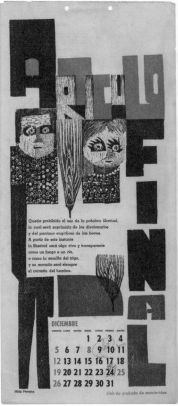

Out with the Madness
Out with the madness, though today I would,
With my heart, I would go,
from street to street,
To tell everyone how much I love them,
To tie a blue ribbon round each tree,
Climb the railings,
To yell out that I love them,
Out with madness,
But today I would
—Líber Falco

Dreams
Bodies, embraced, change position
while they sleep, looking here and
there, your head on my chest, my thigh
on your stomach. And as the bodies
spin, so does the bed, and the room
spins and the earth spins. "No, no"—
you explain to me, thinking you're
awake—"we're not there anymore. We
moved to another country while we
slept."
 —Eduardo Galeano

Letter to Grandma
In winter I'm also happy
But it's cold
And I'm finding it's fun
White white white
Like the paper of the card
On which I write you
 —Andrea Gomez, nine years
old, three years spent in Switzerland

There is snow
I see the snow in Switzerland
Through my television
Through my window
Outside
And I feel happy
I play with in the snow
And I miss Uruguay
 —Patricia Gomez, eight years
old, three years spent in Switzerland

Disappeared
They are in some place / ordered
disconcerted / deafened
looking for each other / looking for us
blocked by the signs and the doubts
contemplating the gates of the squares
the bells of the doors / the old attics
organizing their dreams, their lost
memories
perhaps convalescing from their
private deaths

no one has explained to them with
certainty
if they're already gone or they're not
if they are banners waving or
trembling
survivors or requiem songs

they see trees and birds pass by
and they ignore their own shadows

when they started to disappear
three, five, six ceremonies ago
to disappear like without blood,
like with no face, and with no motive
they saw through the window of their
absence
what remained / that scaffolding
of arms, sky and smoke

when they started to disappear
like to the mirage of an oasis
to disappear without last words

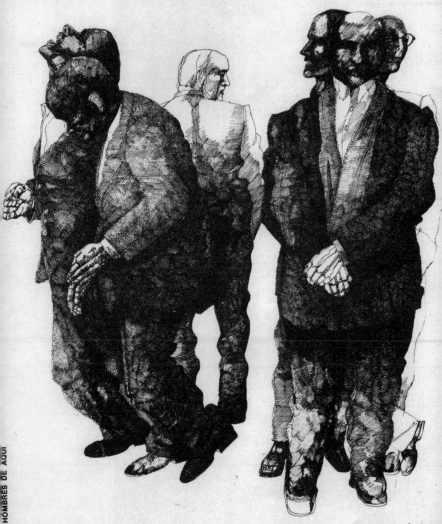

mingo 134/200

de historiales

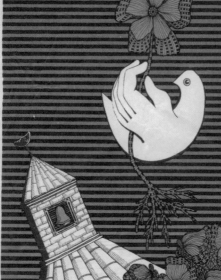

almanaque 1978
club de grabado de montevideo
25° aniversario

VI

*Aquel verano la uva era azul –los granos grandes, lisos, sin facetas–, era
una uva anormal, fabulosa, de terribles resplandores azules. Andando por
las veredas entre las vides se oía de contínuo crecer los granos en un tiempo
inaudito.*

Y en el aire había siempre perfume a violetas.

*Hasta las plantas que no eran de vid daban uvas. Llegaron mariposas
desde todos los rumbos, las más absurdas, las más extrañas; desde los
cuatro rumbos, llegaron los gallos del bosque con sus anchas alas, sus
cabezas de oro puro. (Mi padre se atrevió a dar muerte a unos cuantos y se
hizo rico).*

*Pero salía uva desde todos lados. Hasta del ropero –antigua madera–
surgió un racimo grande, áspero, azul, que duró por siempre, como un
poeta.*

abril

dom.	lun.	mar.	miér.	jue.	vier.	sáb.
					1	
2	3	4	5	6	7	8
9	10	11	12	13	14	15

16	17	18	19	20	21	22
23	24	25	26	27	28	29
30						

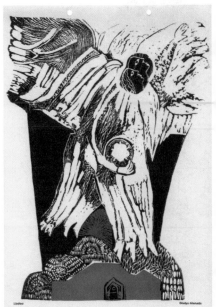

Left: Armando Quintero, offset lithograph, cover/*1978 Almanac*; this page, clockwise: Alejandro Volpe, offset lithograph, April/*1978 Almanac*; Maria Fassio, offset lithograph, July/*1978 Almanac*; Gladys Afamado, linocut, September/*1978 Almanac*.

This is the cover and seven months of internal illustrations from the *1985 Almanac*. The theme of this year was "exile," and none of the artworks were individually authored, but reproduced from designs made by a team including Elbio Arismendi, Beatriz Battione, Héctor Contte, Angel Fernández, Óscar Ferrando, and Ana Tiscornia.

they had in their hands the little pieces
of things they loved

they are some place / cloud or tomb
they are some place / i am sure
there in the southern soul
it's possible that they've misplaced their
compass
and that today they wander, asking,
asking
where the hell is the good love
because they're coming from the hate
 —Mario Benedetti

<u>*The Return*</u>
With your mouth pressed smack
Against my back
I follow the direction
Of immense streets
And on my shoulders
a flag of dust
seems to fall.
Is that the shadow
Of a people
Who after this shadow
Rise up?
Is there a name
Written in these airs
Or is it a trace of smoke
That leaves with my voice?
However, each day
Is completed by the birds

D	L	M	M	J	V	S
	1	2	3	4	5	6
7	8	9	10	11	12	13
14	15	16	17	18	19	20
21	22	23	24	25	26	27
28	29	30				

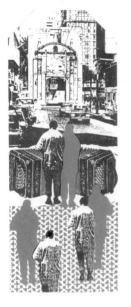

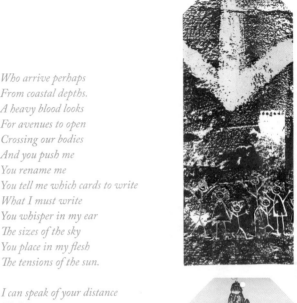

Who arrive perhaps
From coastal depths.
A heavy blood looks
For avenues to open
Crossing our bodies
And you push me
You rename me
You tell me which cards to write
What I must write
You whisper in my ear
The sizes of the sky
You place in my flesh
The tensions of the sun.

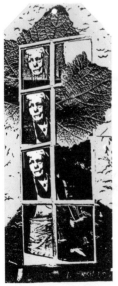

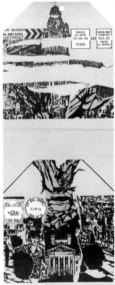

I can speak of your distance
With letters
And listen in my glass
For the sound of the waters
Which one inevitable day
Will enter the sea.
Who are you
After all these years
Used up on thinking
Like a pungent wind
Dissolving in the light?
What will become of you
When my memory
Finds you
And we measure up
The sums of death
The exact numbers of pain
The quantities of ash
And the tears
The lost kisses

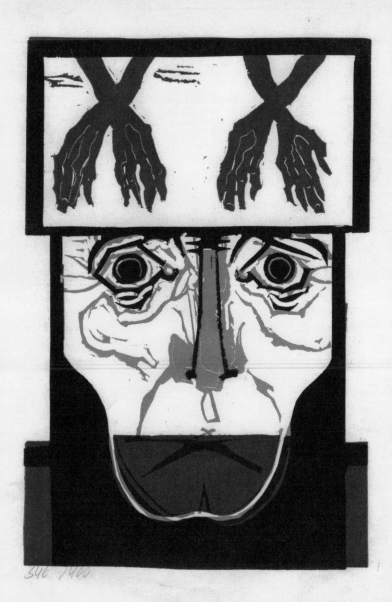

346 1400

The insulted mouths
And those persistent hands
In their final gestures?
What will I be:
What walking thing
With hair and bone
What dear form
Returned to tell
That some bloody way
We'll have to sing.
　　　　—Saul Ibargoyen
　　　　(from *Historia de sombras*, Mexico, 1984)

The French-Chilean theorist Nelly Richard has written about the need for artistic reinvention following political repression, pointing out that the systems that survive, after withstanding the catastrophe, are no longer capable of identifying their own remains.[7] By the late 1980s the club was in a deep crisis of identity, the international socialist network that had held the group together was faltering. Many artists didn't return from exile, and those who did were disconnected.

Leonilda González maintained a correspondence with Óscar Ferrando and other active members of the club in Uruguay throughout her exile, but when she returned after the collapse of the dictatorship she didn't rejoin the collective. By that time the school for fine arts had once again reopened and expanded, and there were new avenues for collaboration; the purpose of the Club was no longer clear. By 1993 the headquarters were being used without political intentions, primarily as a private company. And in 2004 all of the printing materials were sold off haphazardly, along with the entire archive of prints.

The CGM foreshadowed and informed later Uruguayan arts collectives such as the Octaedros, Axioma, and Los Otros,[8] as well the Club de la Estampa de Buenos Aires, the Club de Grabado en Santo Domingo (Chile), and the Club de Grabado en Guadalajara (México),

where Leonilda González spent time in exile. A small Uruguayan collective, entwined within an international socialist alliance, built and spread an alternative model to capitalist and nationalist cultural production, and survived for more than four decades. At ninety-two, González is now concerned with how the historical record of her work will stay afloat. The history of the collective needs to be made vivid, and the precarious condition that the prints are in is worrisome, but there is some small joy in imagining more being unearthed so casually out on the streets.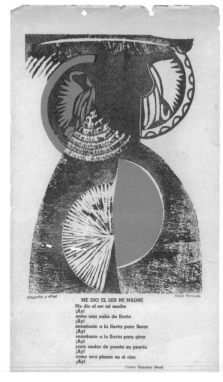

Xilografía y offset · Oscar Ferrando

ME DIO EL SER MI MADRE
Me dio el ser mi madre
¡Ay!
entre una nube de lluvia
¡Ay!
semejante a la lluvia para llorar
¡Ay!
semejante a la lluvia para girar
¡Ay!
para andar de puerta en puerta
¡Ay!
como una pluma en el aire
¡Ay!

Cantar Quechua (Perú)

Endnotes

1 Uruguayan poet, exiled for political militancy first from Uruguay, and again from Franco's Spain.

2 Peluffo Linari in *La pupila* 18 (June 2011): 9.

3 Herbert Read, *To Hell with Culture* (London: Routledge & Kegan Paul, 1963).

4 Entrevista con Leonilda González, in *La pupila* 4 (October 2008): 5.

5 Eliot Weinberger, introduction to *The Green Child* (New York: New Directions, 2013): 13.

6 Peluffo Linari in *La pupila* 18 (June 2011): 19.

7 Nelly Richard, *Fracturas de la memoria* (Buenos Aires: Siglo XXI, 2007).

8 May Puchet, "Una narrativa sobre el arte uruguayo en dictadura, Las instalaciones y estrategias conceptualistas de los grupos Octaedro, Los Otros y Axioma," *Revista Encuentros Uruguayos* 5, no. 1 (Diciembre 2012): 46–55.

Everything but Air in the Air

We are	drinks them
All	with their liquid fear
For all	and is diluted in their warm
Weightless things	thirsty veins
Disembodied	I look at you
Anonymous	You recline on my edge
Names	We rise to each other with risk
Cartels	And for an instant we stop being
Adjectives	Air in the air
Held up by the sun	We are
In the wind	Snails lapped by the sea
A ray of light	Or little things withering
In the middle of the air	And the fire in the taste buds
We are	A splinter of a life shattered
In all	along the path
A shadow of time	That carries the heart
A gust of heat	All
On the path	Except air in the air
Until one	Better to be the mouths
burrows into another's body	Of craters
feels their vital signs	—Graciela Taddey

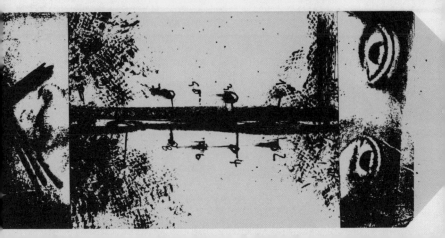

3 PRINT COLLECTIVES

A3BC	Pangrok Sulap	Friends of Ibn Firnas
Japan	Malaysia	USA

Interviews by Alec Dunn

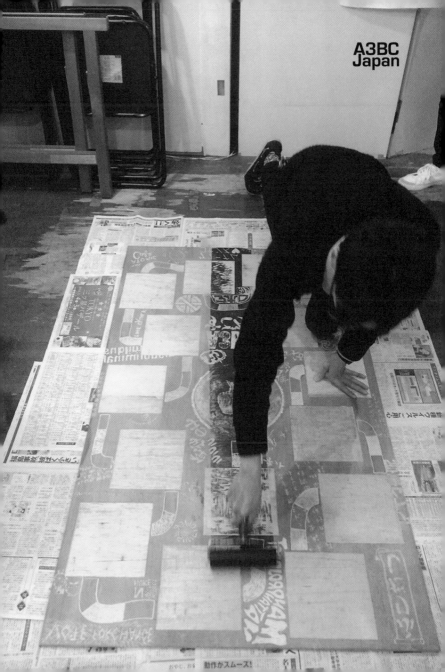

A3BC
Japan

Who is A3BC?

A3BC (Antiwar, Antinuclear, and Arts of Block-print Collective) is a woodblock print collective producing woodcut works focused on antiwar and antinuclear themes. We are open to everyone, so the participants can change anytime.

How did A3BC start?

A3BC was launched by the participants of several woodblock print workshops held in 2014 at an infoshop called Irregular Rhythm Asylum (IRA) in Tokyo.

What have you done so far?

Exhibitions: Sendai 21 Independents 2014 (Sendai City, Japan); No Nukes No War Today 2014 (Maruki Gallery for the Hiroshima Panels, Japan).

Workshops: Yuntaku Takae Festival, Tokyo (solidarity event for Okinawa), Autonomes Zentrum (Koln, Germany) and at many other local infoshops.

Guest workshop and exhibition support: "East Asian Yasukunism—The Yasukuni Fallacy" by Sungdam Hong (a former member of the culture-publicity team for the May 18

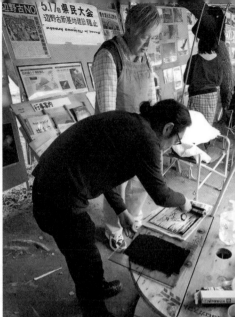

Gwangju Democratization Movement in 1980, South Korea) in Tokyo, 2015.

Actions: Producing banners for the protest movement against the U.S. military base construction in Okinawa, making and distributing placards for the demonstration against the legislative package of two security reform bills (International Peace Support Bill and Peace and Security Legislation Development Bill) submitted by Prime Minister Shinzo Abe's cabinet.

Publishing: A 2015 calendar and now producing a zine themed on antiwar, antinuclear, and DIY woodblock print.

How does A3BC usually work?

Every Thursday night we have meetings and produce art works at the IRA in Tokyo.

What are some common reference points for you as a group: artistically, politically, culturally, socially?

Antiwar, antinuclear, DIY, and having a nice meal.

Tell us about the collaborative work that you do as a group.
We collaborate in the whole process of our woodblock prints, from designing to sketching, and then on to carving and printing.

Can you tell us about the lifecycle of one image: How the imagery was developed/decided upon? How it was made? And what was done with the print when it was finished?
We start our production by talking about the issue on the table. We let the ideas pop up, roll them over, and try to find the whole picture. Also we often adopt remixing or jamming of the existing images (e.g., classical images, book illustrations, etc.) and often use not only papers but also cotton cloths as medium for printing so we can take them outdoors easily.

To take the process of the banner production for the anti-U.S. base movement in Okinawa as an example, what we decided in the first discussion were the

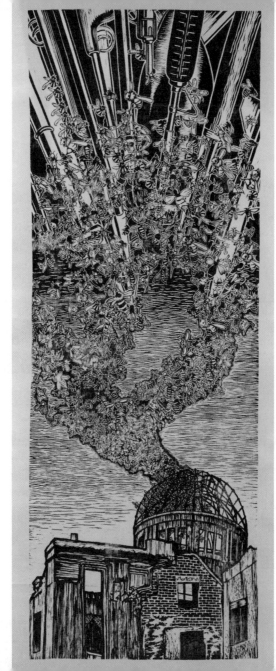

size and composition; we cited the composition from a Japanese classical picture scroll called "Choju-jinbutsu-giga" ("Animal-person Caricatures") to develop it on a 3.6 x 1 m cloth.

Next we drew a miniature draft collectively, and projected and traced it onto a 5.5 mm thick sheet of plywood and engraved it collectively as well. It took about two months before the start of printing.

Finally, in the printing process, instead of using a press

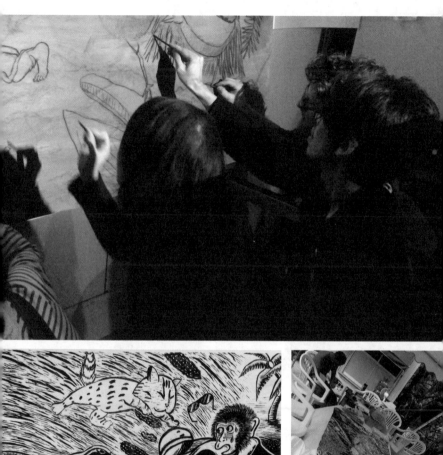

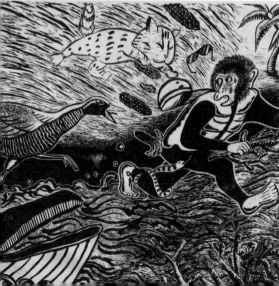

放射
NO.2

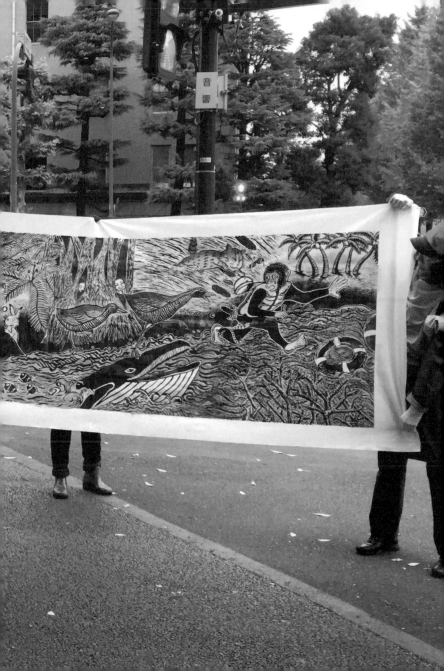

machine, we laid the big block on the floor and put the banner cloth onto it, then stepped on it all together with the participants to make a print. This printing process itself appears to have added the sense of collaboration and sharing among the participants.

Do you have ties with specific social movements and struggles?

We don't have special ties with any specific movements but work with various groups on a project-to-project basis. For instance, our banner was sent and posted at the sit-in site in Okinawa against the construction of the U.S. bases.

How do you navigate the tension between creating functional/utilitarian artwork for political movements and formal experimentation and expression?

Each participant has a different idea about how close or far the distance between politics and their own artworks should be,

however we'll try to navigate through discussions in the group. It appears that the works can often be free from abstruseness when some plot or storylines are attached to the expressions. Also we think that, even without producing explicitly political expressions, the act of fun and free collaboration through a DIY collective itself is political and a way of resistance.

What are some future goals for the group?
Elimination of war and nuclear technologies.

What would the ideal A3BC collective look like?
The principles of the Antarctic Treaty: commons, no-war, and no-nuclear. Given that it is a DIY collective living in Tokyo, which has been turned into one of the extremely capitalistic cities, we regard the present form of ourselves as almost ideal.

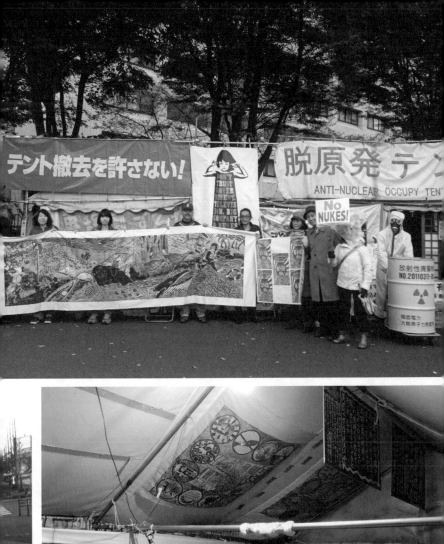

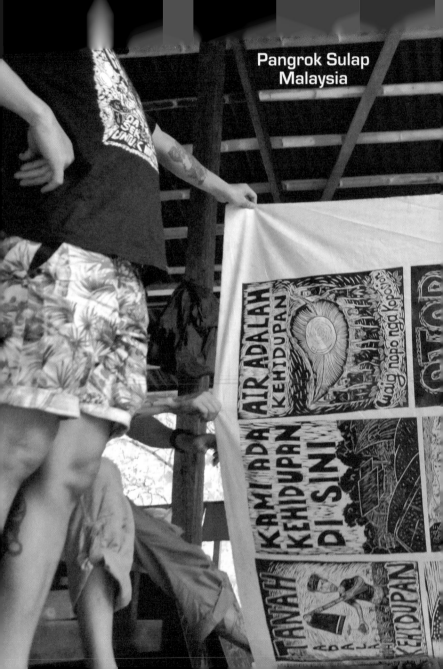

Pangrok Sulap
Malaysia

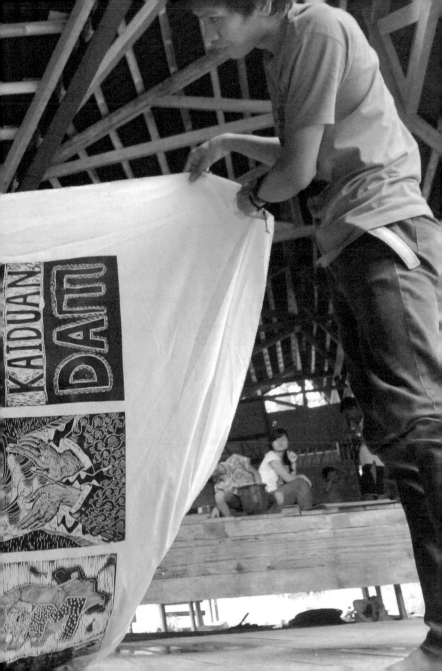

Who is Pangrok Sulap?

Pangrok Sulap is an art collective formed by a group of friends who have the same interest in making art. It was founded by Rizo, Gindung, Bam, and Jerome around 2010. We're all gathered for the same interest. Pangrok means punk rock, while Sulap means a farmer's resting place/hut.

How did you start?

Pangrok Sulap established in 2010, starting from the idea to paint cartoon characters about the happy reality folklore in the State of Sabah. From folklore to become an action. The small communities under the foot of Mount Kinabalu (Ranau) is active in various artistic activities (music, painting, and so on). We fight together in doing art to survive. Here, we believe that every human being is an artist. We would like to invite everyone to do anything related to art as a messenger in our daily lives. Together we fight for the rights of the people, doing charity work in every available space, learning to share knowledge and impetus to all walks of life.

What does Pangrok Sulap do?

Most of the time we're doing block printing. But some of us also know DIY bookmaking, bagmaking, and silkscreen printing. We also do charity and volunteer work.

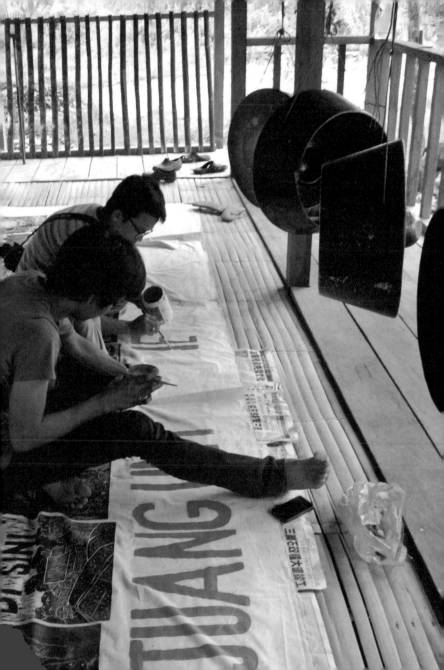

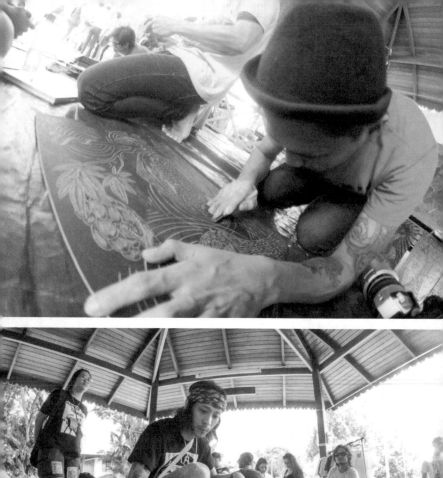
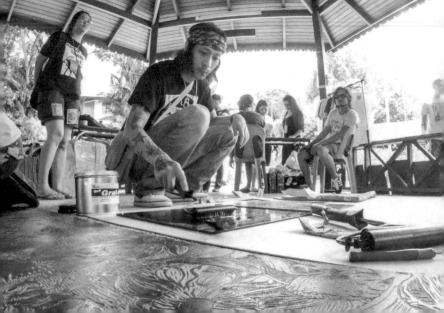

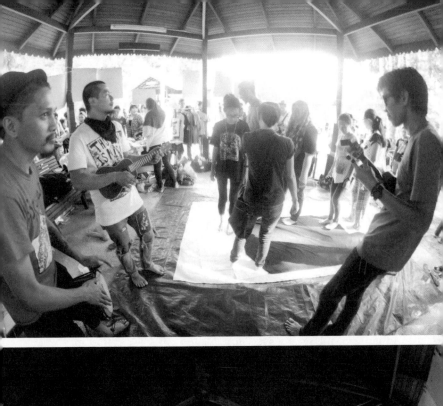

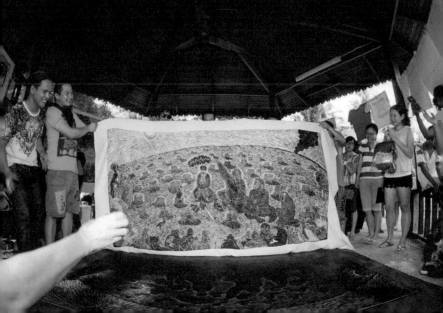

How does Pangrok Sulap usually work—individually, collectively, or both?
Both, but collectively most of the time.

Where is Pangrok Sulap based?
We're based in Ranau. Most of the members are from Ranau and some are from other places in Sabah, Malaysia.

What are some common reference points for you as a group: artistically, politically, culturally, socially?
In terms of message delivery in the artwork. We always ensure that the public can understand directly what we tried to convey in the artwork.

Tell us about the collaborative work that you do as a group?
Normally we'll gather together and discuss the project and what we should do to make it happen. Basically we do community service, and as a group we will work collectively on workshops with communities around us. We do woodcut DIY stuff such as books and often mural and art projects.

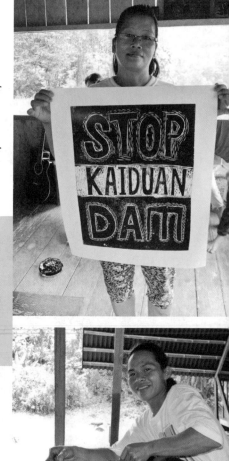

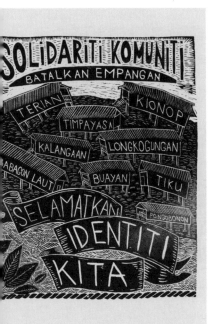

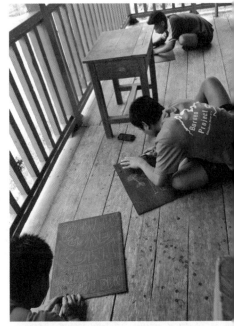

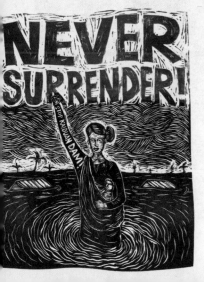

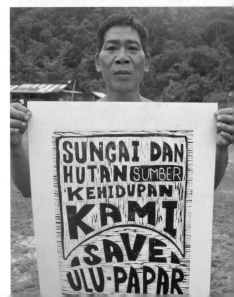

Do you have ties with specific social movements and struggles?
Sometimes we collaborate with people and NGOs.

Have you been able to meet your goals with doing political artwork?
We didn't actually meet our goals, but we still managed to raise awareness.

How do you navigate the tension between creating functional/utilitarian artwork for political movements and between formal experimentation and expression?
The artwork we normally produce is about the issues happening in the meantime, and we think the people will know what we're expressing.

What are some future goals for the group?
We hope what we're doing will influence or inspire more people to do something and to become more aware of their surroundings.

What would the ideal Pangrok Sulap collective look like?
An art collective that brings art to their society.

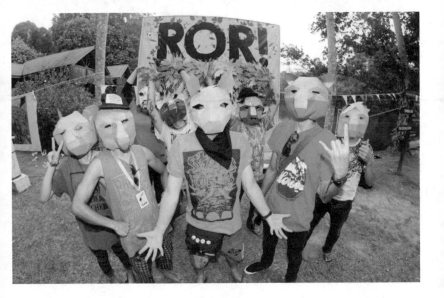

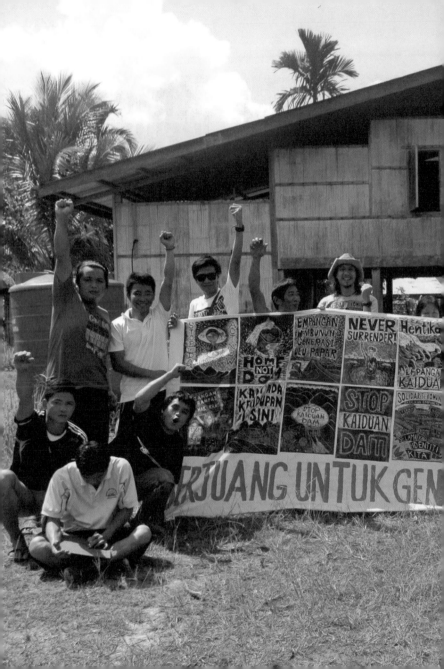

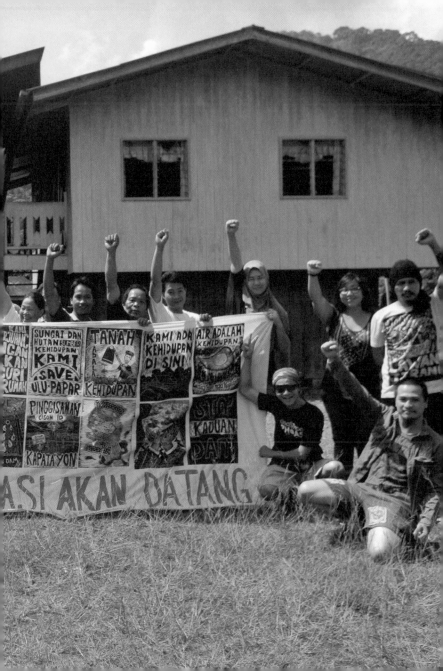

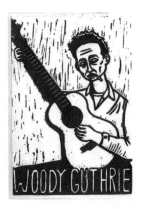

WOODY GUTHRIE

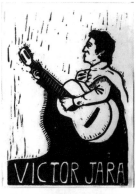

VICTOR JARA

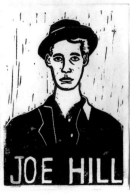

JOE HILL

Who are Friends of Ibn Firnas?

V. Vulpes: Friends of Ibn Firnas is a loose-knit group of visual artists working as illustrators, designers, printmakers, and mural artists for a better world. We formed in Baltimore, where we were attending Maryland Institute College of Art.

Tiger Killhour: Several of us used to go out and wheatpaste together while we were in school. We all struggled individually to define our role and work as we were confronted with the ethical issues and apathy endemic to that scene.

John Fleissner: I think the Occupy movement pushed a lot of people to become active. It was awesome to find other people that wanted to be engaged with the movement. I really felt like it was an exciting time, like something different was happening.

What are some common reference points for you as a group: artistically, politically, culturally, socially?

TK: I think a lot of us were frustrated with what we saw as a sort of onanistic formalism that often ends up being overemphasized in art school at the expense of making work that is engaged with the world around it.

V: The DIY ethos is a big source of inspiration for us, where we don't have

to wait for permission from above to produce something. Some reference points we've been drawn to have been Occupy, Black Lives Matter, environmental issues such as wetlands loss, and labor struggles, particularly at universities.

JF: And print has long been a friend of the anticapitalist movements. Most art movements have been situated on the left, I think that's actually something lost in formal art education.

Where did the name come from?
TK: Abbas Ibn Firnas was an Andalusian inventor who lived during the Islamic golden age. He famously attempted flight with a pair of wings he constructed for himself and survived.

I think when we came up with the name we interpreted his story as a rejection of fatalism, as well as a confirmation of the DIY values that we all share and rely on.

How did you start making political art?
Raj Bunnag: Art is supposed to get the gears in your head

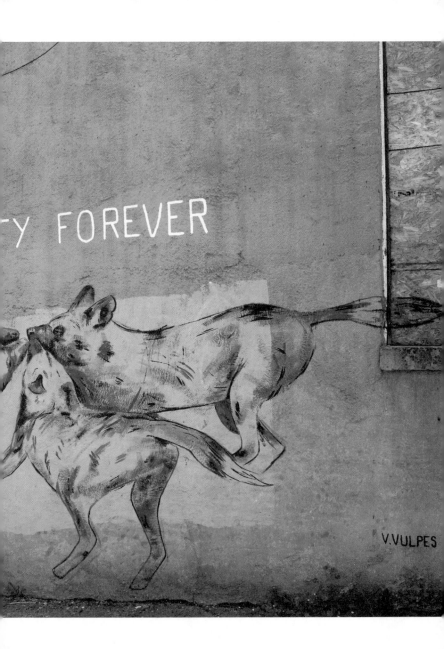

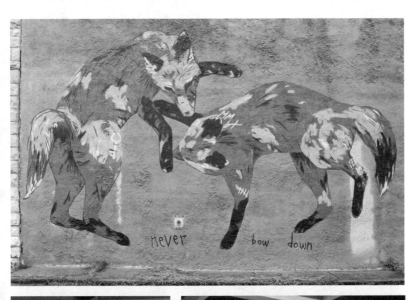

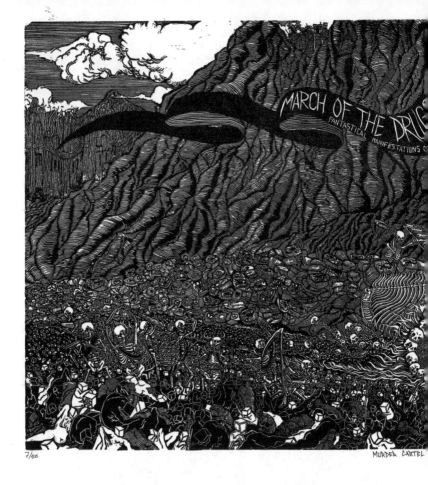

7/50 MURDER CARTEL

moving and make you question systems and other power struc-
tures, not be vapid pieces of color and design that provide no higher
purpose other than "Hey, that's really cool, man." Artists have a re-
sponsibility to be mediators of information and make things more
accessible to others.

V: For me, getting radicalized going to mobilizations in DC and
Pittsburgh produced a desire to contribute to the culture. I was also
getting frustrated with what mostly surrounded me at school and
found an alternative in anarchism and DIY.

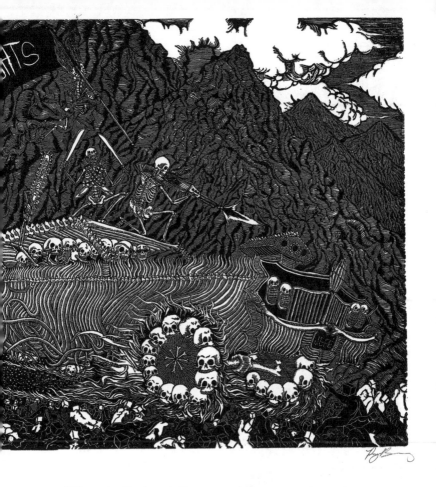

JF: When the Right in Wisconsin eliminated collective bargaining for public-sector workers and workers occupied the capitol, I felt like a pretty major historical event was happening that affected my family. My mom is a public-sector worker in Wisconsin. I wanted to use art to engage, inspire, and mobilize people for the labor movement. Making posters and prints has gone hand in hand with organizing against the police, for labor, and against exploitation.

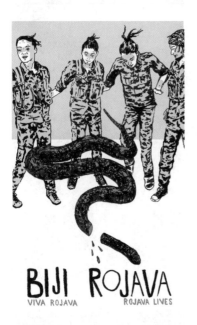

BIJI ROJAVA
VIVA ROJAVA ROJAVA LIVES

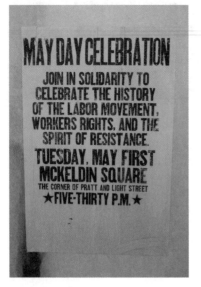

It seems like mostly you have your individual work, and you come together for comics. Is there other collaborative work that you do as Ibn Firnas?

TK: In the past, we have come together to do large scale public art, both legal and extra-legal, and we have a number of smaller collaborative projects in the works. This type of more explicitly collaborative work is generally easier to organize with just a few people who are more or less on the same page and in the same town. Whereas we will try and come together as a whole for larger comics/portfolio.

Why do you choose to make comics? What can comics do that other forms cannot?

V: I like how vast comics can be; they can break down language barriers and can relate to people of all different ages/backgrounds. The potential for story telling in comics is exciting, because the format is not so restrictive as film or literature. I also really like how you can print them cheaply and distribute at a

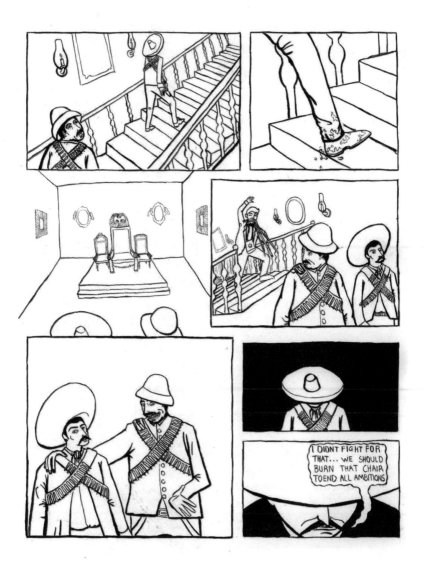

really low cost. It flies in the face of what we were trained to accept at art school.

Do you feel like you've been able to meet your goals with doing political work?

V: You have to take the successes with the failures in terms of meeting goals. We have been able to organize large meetings of students for Occupy with a few nights wheatpasting, but have fallen short at other times. I think a lot of it comes down to timing and ability (or lack thereof) to disseminate the work and the atmosphere of the world around you; sometimes it's out of your control.

How do you navigate the tension between creating functional utilitarian artwork for political movements and between formal experimentation and expression?

V: I make work for political movements in a way I would make work for myself, with more concern for legibility of text etc. I think it's important, especially in posters, to produce work that isn't the same tired ANSWER coalition flier. To keep us sane,

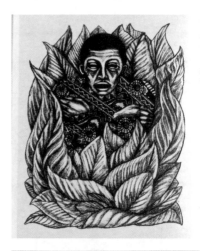

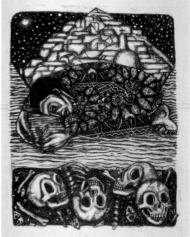

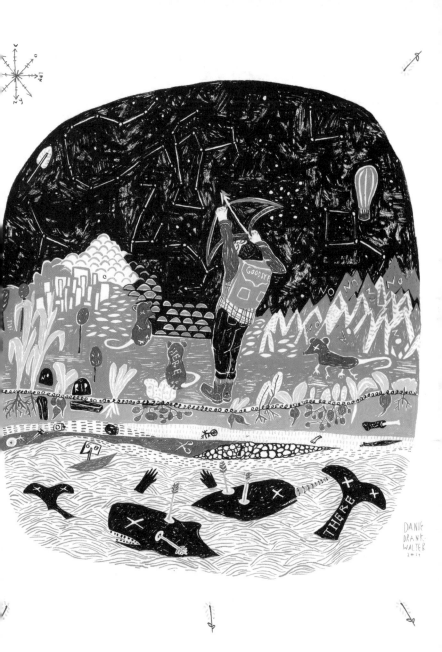

remind us that we're still individuals and even for efficacy, eventually you stop seeing those posters on the street poles. Baltimore is covered in this sort of thing, and the homogeneity of it got really tiring.

What are some future goals for the group?

V: Increase our diversity, become a greater resource, expand our scope, get a press, keep it up!

What would the ideal Friends of Ibn Firnas be like?

JF: I want to occupy a public university that the state is cutting to pieces, take over the print department, bring in all my comrades from all around the country that I've taken the streets with over the past five years and churn out posters to cover the town. Make the trains and the buses stop moving, shut down the ports, lock out the bosses, but have the presses running at full speed to spread the strike.

Is there something you've done as a group that you think of as the best example of an Ibn Firnas project?

V: As we grow we're trying to open up to new types of work but for me, right now the *Every Hundred Feet* compilation is the best example of what we do. It's a fully self-published 56-page compilation with work from 12 artists from all over the country. There's labor poster designs, myths, stories of resistance, goofball irreverence and a variety of political illustration. It sums up Ibn Firnas in its variety. One of the things I really like about the collective is that there's no push to create work that looks like it's of one school. What unites us is our similar hearts. ⑤

Images: Raj Bunnag (64–65), Danie Drankwalter (69), Ibn Firnas (63/bottom, 66/top), John Fleissner (58, 66/bottom), Mattias Kaufmann (70), Tiger Killhour (59, 67), Mataruda (68), Nicole Rodrigues (62), Jade Sturms (71), Kim Te (73), V. Vulpes (60–61, 63/top)

Survival by Sharing

Printing over Profit

Come!Unity Press

FREE SPACE ALTER NATE U

339 Lafayette Street
New York, N.Y. 10012
(212) 228-0322

Freespace at Hunter College
Room 245
68th Street & Park Avenue

CATALOG #13

This list of events is good
until the summer of 1975

C ome!Unity Press was a 1970s queer, anarchist, c o l l e c t i v e printshop located in the center of lower Manhattan. I first discovered Come!Unity by seeing their printing "bug"—or logo—on some of the political pamphlets I had collected, each publication loudly declaring that the printing was done for free, and that the price was sliding-scale. After that I tracked down Paul Werner, an early member of the collective, and interviewed him in his apartment in early 2013. Although he sees himself as marginal to the running of the press, his narrative provides one perspective on this unique political printing project. Below is a liberally edited transcript of a two-and-a-half-hour conversation. We haven't been able to find Lin or Debbie but would love to hear their perspective on C!UP as well.
—Josh MacPhee

Left: Class schedule for the Free Space Alternate University, 1975; right: Fundraising flier placed into each copy of the C!UP reprinting of *Anarchos* no. 4, 1972. Ed. note: All images courtesy of Interference Archive unless otherwise noted.

come! unity press

still needs 450 to replace
the paper, plates and ink
used to print (A)narchos. #4
- these materials need to be
replaced for the other groups
who have future actions and
publicity needs here.
 we need YOUR help to
continue.

How did you get involved in Come!Unity Press?

I stumbled into Come!Unity sometime in 1971. This is basically how it got started: a couple of anarchists—Lin, probably bisexual, and Debbie, gay but never particularly clear and it really was never an issue—volunteered to run an AB Dick 360 offset lithograph press that was being used by the Quaker group, the American Friends Service Committee, to produce literature. The arrangement, at the time I got there was that they could live in the loft where the Quakers worked, and that housed the printing press, and they would run the press. This arrangement was not at all stable. It was not good and was provoked into getting worse as the months went on. Lin and Debbie, Lin especially, were very aggressively anarchist and definitely given to provocation. Their anarchism consisted of the maximum allowance of freedom of expression in all forms and fashions. Clearly the Friends were not comfortable with, say, nakedness or turning the loft into a free soup kitchen.

After much conflict, eventually the Friends decided that the best solution would be for them to leave. This decision arose over the "Kropotkin incident." Among the many visitors to the loft was Kropotkin the cat—this adorable orange tabby kitten that was quite small, maybe six months old. Apparently some of the Quakers weren't fond of the cat. One was allergic, and there were many other tensions going on because they did not see eye to eye with the anarchists. At one point a number of us turned up to find out that somebody had

From left: Liz Willis, *Women in the Spanish Revolution*, second printing by The Lower Depths/C!UP, n.d.; Caribbean Correspondence, eds., *Caribbean Correspondence*, June 1975; *Azalea: A Magazine by Third World Lesbians* 2, no. 1, 1978; John Lauritsen, *Poems & Translations*, self-published at C!UP, 1975; Michael Bakunin, *Bakunin on Violence: Letter to Nechayev*, C!UP, n.d.; Robert Ingersoll, *An Oration on Thomas Paine*, published by John Lauritsen at C!UP, 1976.

taken Kropotkin away. Kropotkin was obviously a political prisoner, and I remember putting up a poster which suggested that should Kropotkin not be liberated, a thrashing might occur. Well, this must have been the last straw and the Quakers decided to move, very politely. "You get the printer, you get the loft, but of course you need to pay the rent."

From then until I stopped visiting, around the summer of '73, Come!Unity was wide open to experimentation. I got a great deal out of this process and I got a great deal out of working with the group. I still put into practice some of the ideas of C!UP, such as not charging fixed amounts. I had started going to C!UP because I wanted to produce a booklet based on the Vietnamese folktale *Ya Trang and the Magic Pearl*. I was in my senior year at Sarah Lawrence College, and I would head down to the city and show up at the press, and part of the stress of the place had to do with priorities—who got to use the press first. So I would come in at five o'clock, and they would say, "Hey, Paul, OK, we'll put you in the queue. We're printing this and printing this and printing that." But then the queue would tend to evolve, and even if I was next in line, there was always something else that would need to go first. Well, perhaps I'm

The One Big Union Structure

of the

INDUSTRIAL WORKERS of the WORLD

Post Office Box 570
Radio City Station
New York, New York 10019
Phone: 477-3355

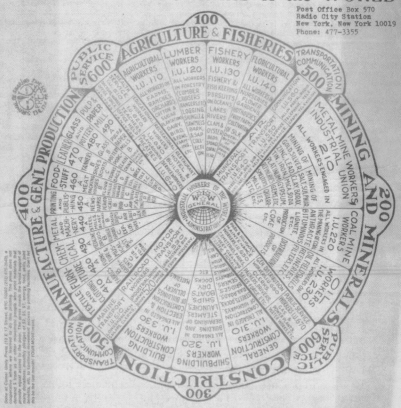

A labor organization to correctly represent the working class must have two things in view.

First — It must combine the wage-workers in such a way that it can most successfully fight the battles and protect the interests of the working class in their struggle for shorter hours, more wages and better job conditions.

Second — It must offer a final solution of the labor problem — an emancipation from strikes, jails and scabbing.

Study the chart and observe how this organization provides the means for control of shop affairs, provides perfect industrial unionism, and converges the strength of all organized workers to a common center, from which any weak point can be strengthened and protected.

Above: cover for a promotional brochure for the IWW printed at C!UP, n.d.; next spread: Paul Werner, "Mugger Love," poster and poem produced as part of the *Verse Gazette*, 1973.

embellishing a bit, but I would hang around, be very patient, and at some point the weed would start getting passed around, especially around eight or nine or ten p.m. The weed would come out and Lin would look at what I had started to print, and would say, "Um, Paul, I think this is a sexist semicolon" [sucking sound of a joint.] "Yeah, I think you might be right," and that would go on for a while. One thing that I've discovered is that pot gets me wide awake and by one a.m., they would all be totally smashed, and they would disappear to go sleep in the loft above the press, and then I would basically have three to four hours of undisturbed time to print on the press, from two to five a.m. So I would start printing, and using the machine for making plates, and loading the thing, and running it all as fast as I could. At about five or six a.m. I'd be printing and I'd see this pair of legs descend from the loft, buck naked, with a couple of testicles hanging right over the press. It was Lin waking up, and he would wander off and have his coffee, and by then it was time to pack up and I would put my stuff away and hope they wouldn't notice that the sexist semicolon was still there.

Then I would make my way up to my classes at Sarah Lawrence. I was nasty, I had been stoned and hadn't slept, my teachers weren't very impressed with me, but what could they do? I'm very glad that I got so much out of it from a theoretical point of view, and I also learned an enormous amount about printing.

Do you know any more about the history of the project?

Come!Unity Press was an anarchist community in New York City in the mid-1970s that offered free access for the publishing of literature and visual propaganda of all sorts; it attracted a wide range of the underserved and unacknowledged: Native Americans, Puerto Ricans, blacks, gays.

Everything at Come!Unity Press was supposed to be free without regard to its position in the circle of production and consumption: free pots of brown rice and beans at the community kitchen, free access to the printing press, free paper to print on, free photographic

MUGGER LOVE

SILENT BLOOD
FLOWS THROUGH YOUR CHEEKS BENEATH YOUR EYES AND FALLS IN SHEETS ACROSS YOUR FOREHEAD.

AND THOUGH THE STREET IS SWEET WITH NIGHT
YOU'RE GOING IT ALONE

WITH YOUR PENNY EYES IN YOUR CHROME-SLOT GLASSES,
YOUR HEELS CLINKING ON THE GROUND.

CRAZY BEGGARS WALK UP
SHYLY. THEY TOUCH YOUR SLEEVE,
YOU LOOK AWAY, THEIR MOUTHES SHAPEN, THEY FALL AND SOFTLY ROLL INTO THE GUTTER.

BUT ALL YOUR MONEY, LADY FACES, QUEEN OF ENGLAND,

LIBERTY,

EVEN ROOSEVELT 'NE WHITE-HAIRED COP,

AREN'T ENOUGH FOR MUGGER LOVE

'CAUSE MUGGER LOVE IS GOING TO DRAIN YOUR BLOOD

AND LEAVE YOU ONLY PUS AND WATER AND NICKEL TEARS.

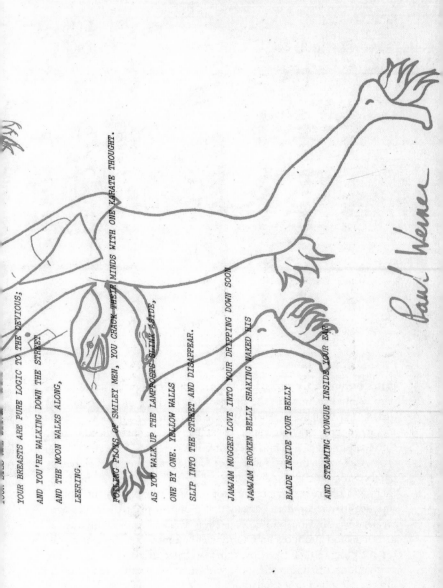

YOUR BREASTS ARE PURE LOGIC TO THE DEVIOUS;

AND YOU'RE WALKING DOWN THE STREET

AND THE MOON WALKS ALONG,

LEERING.

FUNKING PECKS, OF SMILEY MEN, YOU CRACK THEIR MINDS WITH ONE KARATE THOUGHT.

AS YOU WALK UP THE LAMPPOSTS SLINK ASIDE,

ONE BY ONE. YELLOW WALLS

SLIP INTO THE STREET AND DISAPPEAR.

JAMJAM MUGGER LOVE INTO YOUR DRIPPING DOWN SOON

JAMJAM BROKEN BELLY SHAKING WAKED HIS

BLADE INSIDE YOUR BELLY

AND STEAMING TONGUE INSIDE YOUR EAR

Paul Weiner

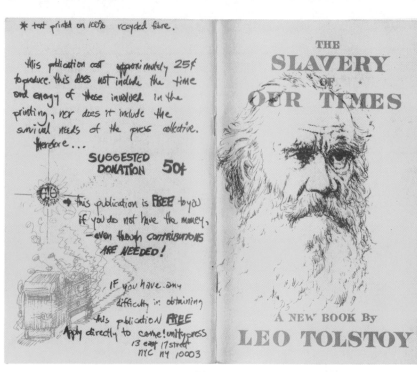

text printed on 100% recycled fibre.

this publication cost approximately 25¢ to produce. this does not include the time and energy of those involved in the printing, nor does it include the survival needs of the press collective. therefore...

SUGGESTED DONATION 50¢

this publication is FREE to you if you do not have the money, –even though contributions ARE NEEDED!

IF you have any difficulty in obtaining this publication FREE Apply directly to come!unity press 13 east 17 street NYC NY 10003

THE
SLAVERY OF
OUR TIMES

A NEW BOOK By
LEO TOLSTOY

Back and front cover, and inside spread, from Leo Tolstoy's
The Slavery of Our Times, edited and printed by C!UP, n.d.

plates to run on the press, free ink, free publications available to all who wanted them, with the proviso that nothing in turn could be distributed that might encourage or advocate for others to spend money for anything. Of course, participants were encouraged to put into the project as much as they took out.

As a result the productions of Come!Unity Press developed a patched-together aesthetic that could be called pre-punk. Because there was no particular pressure for any one user to buy his or her supplies it was common for any one group to print their message on whatever previously-used paper was available, and in any case a printing press produces an enormous amount of waste paper ready for recycling, either from overruns or failed trials. This gave our productions a palimpsestic look, with images or text often printed directly on top of other, faded or illegible images or texts. There was

Despite Leo Tolstoy's status as a great writer, the social ideas which inspired his novels as well as pamphlets such as this one, are scarcely alluded to in connection with his name. It is for these ideas, however, not the fame of their author that we choose to reprint "The Slavery of Our Times", for his beautiful delineation of some truths which we feel to be basic and even more important, that he tried sincerely to live according to his ideals, as many people have tried, are trying and will continue to try, whose names will not become legendary.

"The Slavery of Our Times" is the first of a series of pamplets on anarchism many of which will not have famous authors or not have authors at all, but come instead from the collective process of sharing

→ IF the ideas of what we are doing, turns you on, please contact us. the press collective urgently needs more people to help with printing, maintenance and all aspects of PRINT COMMUNICATION.

abundant use of the "rainbow" effect, which consists of loading different colors to run at once from a single ink trough so that they gradually blend into one another. Of course one could always add different inks to the trough as the press was running, or even smear dabs of color directly onto the metal plate—a rather dangerous game since the plate was revolving at high speed. A rainbow effect is difficult to duplicate in any consistent manner: one would have to take the project to a commercial printer, separate the colors, and run each color separately with accurate registration. As we realized, "consistency" is one of those bourgeois aesthetic values whose sole function is to convey the impression that the work is "professionally" done, meaning costly. It enforces a value system in which "self-expression" is believed to be at odds with public and political efficiency; it draws a distinction between work for hire and labors of love.

FORUM – MAY 1 (MAYDAY)
THURSDAY – 12 – 3 PM – REMSEN 105
QUEENS COLLEGE

PSYCHIATRIC OPPRESSION

GROUPS AND SPEAKERS TO APPEAR:

"MENTAL PATIENTS" LIBERATION PROJECT- Founded in June 1971 by former "Mental Patients" having been subjected to brutalization in mental hospitals and by the psychiatric profession. At the first meeting of MPLP held at the Washington Square Methodist Church, a Bill of Rights was prepared;for;in almost every state of the union a "Mental Patient" has fewer de facto rights than a murderer condemned to die or to life imprisonment. An activist group together for almost four years now, MPLP has worked to abolish forced "treatment" and involuntary committment, and has helped free many people who have been put away against their will. MPLP maintains a storefront at 56 East 4th St., (212) 475-9305; Meetings are held Wednesdays, 7:30pm at The Basement Coffee House, 155 East 22nd St. N.Y.C.

RELEASE- A new community organization of former "Mental Patients" working together on the Upper West Side of Manhattan, N.Y.C. to change the conditions that cause many to end up back in hospitals. They are planning to initiate co-operatively run self-help programs, and leave being "Mental Patients" behind. Meetings are held Mondays, 7:30pm at The Goddard-Riverside Community Center, 161 West 87th St. N.YC.

OUT OF THE SHADOWS/QUEENS VOCATIONS FOR SOCIAL CHANGE- A newly formed collective of former "Mental Patients" in Queens, dealing with Queens Institutions. Formed by members of MPLP and Queens V.S.C., the collective offers " natural alternatives" to psychiatric oppression and psychiatric drugging; through research into and alternatives to "medication", alternative job counselling, legal aide, and free expression through the arts and music. Meetings are held at Queens College at 153-11 61Rd., Flushing, N.Y., Thursdays 7:30pm.

"MENTAL PATIENTS" RENAISSANCE- c/o Tony Colletti, P.O. Box 1277, Peter Stuyvesant Station, New York, New York 10019.

"MENTAL PATIENTS" ASSOCIATION- Vancouver, British Columbia.

RUTH BUCK- Former guidance counsellor at Franklin K. Lane High School, now running for a seat on Local Public School Board no. 25 encompassing the Flushing-College Point-Whitestone area.

Why are we helping you?
an alternative is a choice.

we create and share
our access to press equipment for a reason...we want to support
those publications that we feel have the most insecure
survival—those that are open to anyone, regardless of
their ability to contribute money.—people who are
making this one of their immediate goals.

if we want it to continue, we have to support it.
receiver-supported

it doesn't work? well that depends on what measure you have for
success. perhaps being open to contributions other
than money —de-emphasizing the accumulation of power
in money-is important enough!

there are hundreds of printshops in NY that meet
the needs of consumers. people who feel that they
must charge for their access, should go to printers
that feel the same way.

we don't want to participate in withholding information,skills,entry for lack of bread.
we can never ask first for participation-in-maintaining-the-war-machine in order to connect to a LIFE-
CULTURE! ———————— demand participation in the wage-slave machine 'in order to
survive' everytime they use a price-only ONE way of contributing)

those of us that have subsistence or no salaries are
typically excluded from events, publications, that re-
quire admission passports of money.we won't put our
energies into these things.we exchange our energy, we
don't have money to exchange

what are the realities of our continued existence ? our costs from those who demand it: the lords of the
land, the 'public utilities.' the paper, cutting, trucking, ink, plate companies...

our primary purpose is not
printing at all...but a means But we do need money!
to explore new ways of work-
ing/living together. a chance
to study ourselves, using
printing(a common need)to create a space where other forms
of participation are often more
important than money. this is
not a cheap printshop to serve
reallocatting $ as a resource consumer trips.

we are therefore into the busyness of subverting and converting resources to
the support of a community of movement collectives-which, in turn support the
people of this counter-culture.

Left: "Psychiatric Oppression Forum" flier, 1975; above: page from *Alternatives to Come!Unity Press* brochure, printed by C!UP to encourage people who wanted to print commercial work to find printing elsewhere, n.d.

I think one also has to be aware of the institutional tensions that were built around the press. Lin and Debbie, to a great extent, encouraged tensions. I ascribe that to an almost fascist aspect in that they definitely encouraged ego aggression. The anarchists did not particularly feel that they could or should interfere on the subject of violence, which I found very interesting. Weird numb arguments, over a large pot of beans and who got to eat the beans. There was always that kind of low-level thing going on. It was quite unpleasant. It also worked its way into the way things were printed.

Looking back at my time at Come!Unity Press, I remem-ber now that only once did we ever hold a meeting to decide what

of the popular movement and the principles of freedom and revolution.

The issue of local control versus the centralized state is being joined today whether we like it or not. A long-range historical dialectic toward state capitalism pits the neighborhood against the megalopolis, the village, town, and small city against the State governments and Federal government, the municipality against the national state. Whether demagogues like Wallace will be permitted to exploit this confederal tendency, whether a liberal opportunist like McGovern

proposals entail a process, one that of forms of a Miami development of pop this development to is genuine revolution offensives" that lap cheap ego-tripping o not the compromise the lavatory-oriented on Fridays.

layout by gina blumenfeld

since $459.50 in paper, ink, plates of the community inventory been replaced from printing this issue, contributions to should be sent to

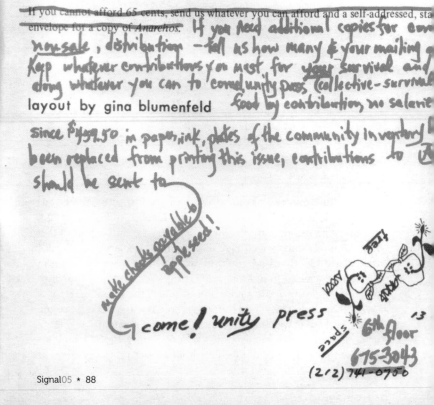

make checks payable to oppressed!

come! unity press

free space

6th floor 13

(212) 741-0750 675-3043

C!UP editing within the second printing of *Anarchos* no. 4, 1972.

e grass-roots educational
spectacular rewards in the
but rather a painstaking
ciousness and activity. Yet
e work we contribute to it
is—not the phony "spring
ummer vacations, not the
, Washington and Miami,
cGovern on Mondays and
sm" of the Weatherpeople

The*Anarchos* Group
June, 1972

type of work to produce, or how. Discussions and tensions were invariably, and indistinguishably, about access: access to the loft, access to the press, access to the beans and brown rice eternally waiting to be shared.

If you look at the output of C!UP, it represents all these tendencies of the Left: queer liberation, free education, black nationalism, anarchism, labor organizing. Why did all these groups coalesce and fight in this little loft? Why all the intersection, what brought all these people in the door, because in the larger movement they didn't always cross paths?

What's that line from Bob Dylan? "There was music in the cafés and revolution in the air." There was a great deal of cross-fertilization; it just wasn't on the formal organizational level. What brought people together was that these guys had a press, and people thought they could get a freebie. But this was unstable. I remember the first time that somebody came in who wanted to do something with the press for a straight feminist group, something that could be considered commercial

work, and everybody sat around and talked about it and turned it down. People wanted access to the instruments of production. But it wasn't simply a question of walking through the door, absolutely not. Lin and Debbie would bait you and tell you you weren't politically correct, but they were at least interested in getting people to have these discussions, they were interested in getting people in the door and learning how to print. Whether the groups interacted, not any more than they would interact at an antiwar demonstration. In the early 1970s, you could go to a rally and see people from wildly divergent groups and orientations. It was wonderful, people would come to marches and start arguing. And then at some point in the mid-'70s people started deciding who should and shouldn't have been participating in their marches.

The approximate cost of producing this pamphlet is 25¢. This figure includes the price of paper, ink, plates, chemicals, electricity and other supplies used in printing. It does not include the labor of those who worked on the pamphlet or of the collective who maintain Come!Unity Press as a cooperative, anti-profit, movement press where layout and printing skills are freely taught. The lowest commercial rate we estimated for this job would make the actual cost of each pamphlet 43¢. If you can afford a donation, please give generously. Nobody will be refused this publication through lack of money.

...'AMERICAN MOVEMENT

...mean to be a college student in 1974? ...'e confused, alienated, and just plain bored. ...hough being a student means little or nothing ... fact is that even those of us who will ...hallowed halls" with a practical knowledge ...will end up teaching in public schools, ...arge impersonal corporations, or spending ...art of some bureaucratic department of ...es. Many of us will end up as taxi drivers. ...at is to blame for this rotten situation.

...e American Movement (NAM) believe that the ... of the university as well as the present ...hole American society is a function of the ...social system under which we live--Capitalism. ...further to say that these conditions can only ...by socialism--a society whose basic aim is ...lopment of every individual. A society where ...ntrol the places where we live and work. We ...me say over the subject matter and how it's ...university.

...ge NAM hopes to work on issues which affect ...s and as part of a larger society. Examples ...eme are fights against budget cutbacks, ...he extension of open admissions, fighting ...ancial aid and a possible study group on ...he university. We are also trying to ...cialist perspective inside the Impeachment ...nally we will present educational and ...rams around such issues as the coup in ... continueing involvement in Indochina.

...'e interested or would like to know more ...in at 939 8633

"DIS-ORIENTATION WEEK"

feb. 19-22

PEOPLES FAIR

PRESENTED BY: COALITION

&

New American Movement

Left: statement on the inside front cover of Michael Bakunin, *Bakunin on Violence: Letter to Nechayev*, C!UP, n.d.; above: flier for "Dis-Orientation Week," alternative educational program at City College of NY, 1974.

What are your politics?

I'm an anarcho-syndicalist. I always have been. I would really describe myself as a Marxist but if someone asked me specifically I would say that I'm an anarcho-syndicalist, I should clarify that this came about because of my involvement in the uprising in May '68, in which I was involved not as a student but as an actor and a member of the CGT, the left-center union in France. So anyway, working with these anarchists reinforced my belief that one organizes not simply in the workplace but that work itself is where organization must happen.

There must have been a fundamental belief in propaganda, to run a press?

C!UP's output is not ideological material. You'll see for instance that a lot of it is poetry. One of the wonderful achievements of Come!Unity Press was that it allowed me to produce a list of

This page: *Gay Youth of New York* poster, 1980, image courtesy Lincoln Cushing/Docs Populi; opposite: a page from *Ya Trang and the Magic Pearl*, published at C!UP by Paul Werner as a benefit for Medical Aid for Indochina.

free poetry readings across the city. This idea of free listings got picked up and ran by others into the 1980s and '90s. [And can be seen as a precursor to the free punk and DIY music show listings that are still produced in many cities.—ed.]

The term propaganda is not necessarily a negative, but it assumes that the purpose of media or cultural production is to create a counter-hegemony. I think that one has to consider that there are other politically valid uses of the production of media. These are exemplified by an exchange where I thought Lin was being a little bit of a fascist, I think over the fact that somebody had assaulted me and he seemed quite indifferent to it. I turned around and said, "Yeah, sure, tell me about the coming revolution, Lin," and he said, "It's here." Now I might have rightly responded, "Does your revolution involve physical attacks?"—but I also got his point, which is that we act as if the revolution has already happened. Take your desires for reality, behave as if you are not trying to overthrow a society, behave as if you are trying to live the new one. You don't claim to define what things should be or persuade others

BY AND FOR PEOPLE WHO HAVE BEEN ON
THE RECEIVING END OF PSYCHIATRY
FOR TOO LONG!

From the Brooklyn House of Detention

SUMMER 1974

...the west wind
fans the embers
of my burning
anger as I
gaze through
the penitentiary
bars and
view the
Statue of
Liberty...

This page, from top: The Center for Constitutional Rights, eds., *From the Brooklyn House of Detention*, 1974; flier for Puerto Rican History Classes within *Appleseed Free Space*, July–August 1972; Cover for *Appleseed Free Space*, July–August 1972.

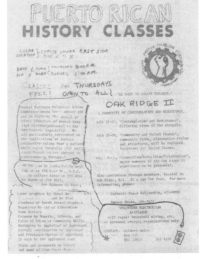

Opposite page, from top: cover of *Premonitions of Crystal Night*, a broadsheet containing a poem by Judith Malina, published by C!UP, n.d.; *Take The Land* 1, no. 1, 1974, published by The Republic of New Africa at C!UP; *Rising Up Crazy* no. 2, 1973.

POLITICAL ARENAS ARE NOT FREESPACE

NEW JERSEY'S SECRET KONCENTRATION KAMP PROJECT

HITLER WAS ABLE TO BUILD KONCENTRATION KAMPS IN GERMANY BY USING THE "BIG LIE" TO MAKE THE JEWISH PEOPLE THE SCAPEGOAT FOR THE ECONOMIC DEPRESSION THAT SWEPT GERMANY DURING THE 30'S. THE STATE OF NEW JERSEY IS USING THESE SAME TATICS TODAY IN WHIPPING UP PUBLIC HYSTERIA TO SEND ITS BLACK PRISONERS 1500 MILES AWAY TO A FEDERAL MILITARY KONCENTRATION KAMP IN FORT LEAVENWORTH, KANSAS. THEY ARE USING THE "BIG LIE" AGAINST SUNDIATA ACOLI (s/n CLARK SQUIRE) TO SHIP HIM OUT FIRST.

IF THEY ARE SUCCESSFUL THEN ANY PRISONER FROM ANY STATE WILL BE LIABLE TO THE SAME TREATMENT—NOT ONLY FOR SHIPMENT TO FT. LEAVENWORTH BUT ALSO TO ANY OTHER REMOTE PLACE SUCH AS ALASKA, THE EVERGLADES OR DEATH VALLEY. THE PRISONS ARE OVERWHELMINGLY BLACK.

ALMOST EVERY BLACK PERSON, NO MATTER HOW HIGHLY PLACED, HAS SOME RELATIVE, FRIEND OR ACQUAINTANCE LOCKED AWAY IN THESE DUNGEONS. IF THE STATE OF NEW JERSEY IS ALLOWED TO TO SHIP SUNDIATA TODAY, IT IS ONLY A MATTER OF TIME BEFORE YOUR LOVED ONE, RELATIVE OR FRIEND IS SHIPPED OUT TOMORROW...AND THE DAY AFTER IT COULD BE YOU OR ANY OTHER BLACK PERSON (AS THE JEWS OF GERMANY WELL KNOW).... AND THE DAY AFTER THAT IT COULD BE ANY POOR OPPRESSED PERSON OR ETHNIC MINORITY IN GENERAL.

NEW JERSEY HAS ALREADY INSTITUTED CRUEL BEHAVIOR MODIFICATION UNITS IN ITS PRISONS. THESE UNITS ARE NOTHING BUT SECRET HORROR CHAMBERS WHERE SELECTED PRISONERS (95% IN UNITS ARE BLACK) ARE BRUTALIZED, TERRORIZED, EXPERIMENTED UPON WITH MIND DESTROYING DRUGS.AND INJECTIONS WHICH HAVE THE SAME EFFECT AS ELEC-

Clark Squire

TRIC SHOCKS—AND EVEN SHOT AND MURDERED! ALL THIS IS COVERED UP WITH THE "BIG LIE".

EVERY BLACK, POOR AND OPPRESSED OR ETHNIC MINORITY PERSON HAS A PERSONAL STAKE IN HALTING THE TRANSFER OF SUNDIATA TO A KONCENTRATION KAMP—AND IN THE DISMANTLING OF ALL BEHAVIOR MODIFICATION TYPE LOCK-UP UNITS IN THE PRISON SYSTEM.

TODAY IT'S SUNDIATA-TOMORROW IT COULD VERY WELL BE YOU-JUST ASK THE JEWS IN GERMANY ABOUT IT.

SO WRITE, CALL, TELEGRAM GOVERNOR BYRNE OR COMMISSIONER MULCAHY, DEPT. OF CORREC-TIONS-BOTH ADDRESSES ARE--THE STATE HOUSE, TRENTON, NEW JERSEY AND DEMAND A HALT IN THE SCHEME TO TRANSFER SUNDIATA TO A KONCENTRATION KAMP-AND DEMAND THE DISMANTLING OF THE SINISTER BEHAVIOR MODIFICATION UNITS IN THE NEW JERSEY PRISON SYSTEM.

FREEDOM COMMITTEE FOR SUNDIATA ACOLI (clark squire)
EAST TRENTON COMMUNITY CENTER
208 N. CLINTON AVENUE
TRENTON, NEW JERSEY 08609

Done at Come! Unity Press (13 E 17 Street, NYC 10003 (212) 675-3043), a cooperative where we learned to do this printing. The press does not demand $ from us or other movement people who print materials that provide equal access to the poor. The press needs the broad support of many donations: monthly pledges of $2, $5, $7, energy, food, skills, joint benefits, etc. to continue movement access to printing facilities. Don't let this be the last month! YOUR MOVEment.

This page, from top: "New Jersey's Secret Koncentration Kamp Project," flier, n.d.; opposite page: internal page spreads from Peggy Kornegger's *Anarchism: The Feminist Connection*, published by C!UP, n.d.

Partial success at leader/"star" avoidance and the diffusion of small action projects (Rape Crisis Centers, Women's Health Collectives) across the country have made it extremely difficult for the women's movement to be pinned down to one person or group.

Feminism is a many-headed monster which cannot be destroyed by singular decapitation. We spread and grow in ways that are incomprehensible to a hierarchical mentality.

to act in such and such a way. In a context like that, what is the purpose of propaganda?

And as I said, Lin in particular was not interested in persuading others. It has its extremely bad sides which dangerously approach fascism, and to do that is to create an exclusivity. The field created by C!UP was indeed very exclusive and exclusionary, but it was a field that claimed to be the field of anarchist living. Within this, whether one propagandized is irrelevant. This way of thinking and being overlaps with the

"Feminist" capitalism is a contradiction in terms. When we establish women's credit unions, restaurants, bookstores, etc., we must be clear that we are doing so for our own survival, for the purpose of creating a counter-system whose processes contradict and challange competition, profit-making, and all forms of economic oppression. We must be committed to "living on the boundaries,"[21] to anti-capitalist, non-consumption values. What we want is neither integration nor a coup d'etat which would "transfer power from one set of boys to another set of boys."[22]

What we ask is nothing less than total revolution, revolution whose forms invent a future untainted by inequity, domination, or disrespect for individual variation—in short, feminist-anarchist revolution. I believe that women have known all along how to move in the direction of human liberation; we only need to shake off lingering male political forms and dictums and focus on our own anarchistic female analysis.

productivist theory of culture, which argues that cultural production is no different from any other form of production—it has to be its own justification. You use the instruments of production in a certain way which is utopian. Ultimately you can take this back to the thought of William Morris. ⑤

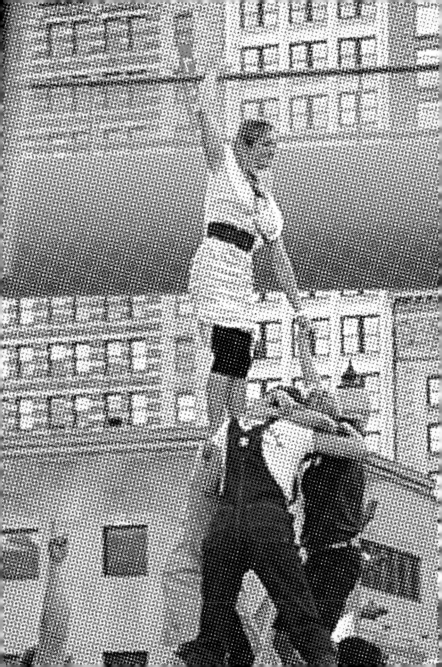

THE
PYR
AMID'S
REIGN

ERIC TRIANTAFILLOU

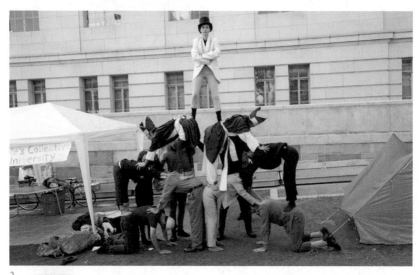

2

Back in October 2011, during a massive Occupy Wall Street rally in Chicago, a human pyramid suddenly rose out of the teeming crowd. Those on the bottom and middle layers were dressed in "workers" clothes, while a lone woman stood on top wearing a black and white evening gown [1]. In response to the crowd's jeers— "Bring down the pyramid!"—the bottom layer began to shudder, the whole pyramid swayed precariously, and then collapsed in spectacular circus-tumbler fashion. The tumblers repeated this performance, building and collapsing the pyramid several times, to the intensifying thrill of the crowd.

The image of a vertical structure rising from and falling level with the crowd powerfully performed the idea of horizontalism that was so central to the Occupy movement. The hierarchical social stratification of the pyramid, with its simple message—if those on the bottom remove their support the whole thing comes crashing down—visually reinforced the movement's enduring message of the 99% as the agents of radical change. On that same day another human pyramid was performed at an Occupy protest in Los Angeles [2].

The popular use of the social pyramid as a symbol of economic inequality seems to increase in times of crisis. The

pyramid was often invoked by FDR in his fireside radio chats during the Great Depression, and President Obama frequently uses it to describe economic inequality in American society, particularly after the 2008 financial collapse. But it is not only those on the left that invoke the pyramid. At another Occupy rally in front of the Chicago Board of Trade, financial traders put signs in the building's windows that mockingly stated, "WE ARE THE 1%." At one point a window opened and a hand popped out, releasing hundreds of fliers that read:

We are Wall Street. It's our job to make money. . . . The Obama administration and the Democratic National Committee might get their way and knock us off the top of the pyramid, but it's really going to hurt like hell for them when our fat asses land directly on the middle class of America and knock them to the bottom.

The social pyramid continues to be used by a broad spectrum of interests across the U.S., from social movement activists and academics to mainstream media pundits and politicians, from communists to free market libertarians. It can also be seen in art world contexts, like a 2012 installation made of women's handkerchiefs [3], or a 2011 marzipan and chocolate layer cake pyramid that gallery patrons were invited to eat—a riff on Marie Antoinette's infamous quip [4]. There is even a school of economic thought called BoP (Bottom of the Pyramid) that seeks to develop the entrepreneurial market potential of the three billion people at the "bottom of the pyramid" who live on less than $2.50 a day.

But the proliferation of the social pyramid raises questions about the kinds of ideological and affective work it is doing, about the potential and the limitations of visual representations to

3

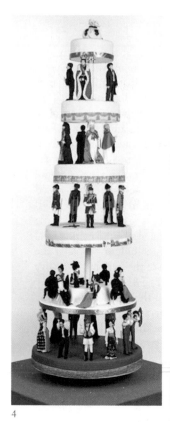

4

both incite and explain. What I suggest below is that the image of capitalist society as a pyramid obfuscates rather than reveals the source of social domination that is specific to capitalist social life. It does this by locating the source of capitalist social domination in hierarchical power relations as such, in the image of a social structure in which a small group of people possess all the power and mobilize it through a militarized state, to dominate everyone else.

A VERY BRIEF HISTORY OF THE CAPITALIST PYRAMID

The image of society as a pyramid has a long history, from Egypt to the Hindu caste system to European feudalism and on up to contemporary global capitalism. Particular social

groupings and power dynamics within the pyramid vary based on the specific context, but what remains the same across time, space and culture is the image of a society that is hierarchically structured, typically according to a division of labor, with a powerful few at the top and the laboring masses at the bottom.

We can see from their costumes that the Occupy tumblers were performing *Pyramid of Capitalist System* [5], an iconic representation of class oppression and struggle. Still widely circulated today, *Pyramid of Capitalist System* was produced in 1911, probably by Serbian socialists who, fleeing state repression, had immigrated to the U.S. at the end of the nineteenth century. It was used as propaganda to mobilize workers in Great Britain, which would account for the king on the top tier. In the U.S., it first appeared on the cover of the August 1912 issue of *Industrial Worker*, the newspaper of the Industrial Workers of the World, the organization to which it is typically attributed.

Pyramid of Capitalist System clearly references the earlier *Pyramid of Autocracy* [6], produced in Geneva in 1901 by the artist Nikolai Lokhov for the exiled Russian Union of Social Democrats, of which the Bolsheviks were a faction. The Russian text at the bottom reads: "The time will come when people will rebel; They will finally straighten their curved spine; And with a collective jolt of their shoulders; Will topple this oppressive object!"

Immediate pre- and post-revolutionary Russia has the strongest tradition of capitalist pyramid imagery. The USSR and its Eastern European satellites would often have tumblers perform large human pyramids during official state events as an example of collective cohesion and productivity. Lokhov may have been re-crafting an even older version, *Pyramide à Renverser* (Pyramid to Topple) [7], produced in Brussels in 1885. This is the earliest class-based (i.e., capitalist) pyramid I have found. On top is the bust of King Leopold II of Belgium who reigned from 1865 to 1909. *Pyramide à Renverser* was disseminated in the pages of the Belgian Communist Party newspaper, *Le Drapeau Rouge*, primarily to challenge the political power that rested in the hands of a minority.

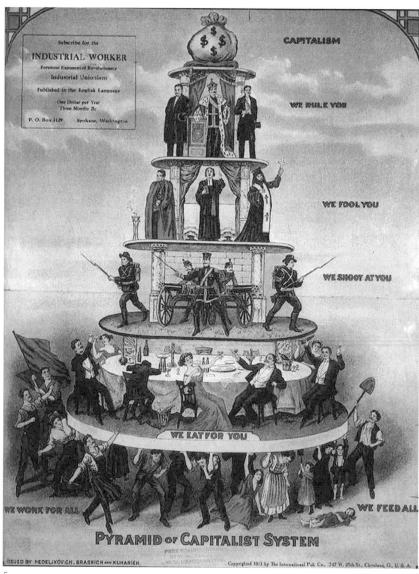

The differences between these pyramids are significant. For example, the workers in the 1885 *Pyramide à Renverser* appear woefully resigned to their station, whereas in the 1901 and 1911 pyramids they are agitating, waving a red flag, engaged in class struggle. Also, rather than occupying a place outside social labor, (white) women and children are represented as an integral part of what constitutes society. This not only indicates shifts in the social conditions and attitudes of the time, it also demonstrates a much broader intended audience. Struggles over women's suffrage, political representation, employment rights, regulating the length of the working day and minimum employment ages, liberalizing property rights, and marital law had all been forced into the picture by first-wave feminism.

The layer-cake tiers in the 1885, 1901, and 1911 pyramids correspond to capitalist class relations. However, these class relations emerged historically from the precapitalist social divisions we see in *The Three Estates of the Realm* [8], a woodcut from 1488 by the German artist Jacob Meydenbach. *The Three Estates*

depicts a feudal European social order that, loosely pyramidal in form, is distinguished by a tripartite social hierarchy that identifies humans with specific functions, denoted by textual labels in Latin: "Tu supplex ora" (You pray) = the clergy; "Tu protege" (You protect) = the nobility; "Tuque labora" (You work) = the commoners; and God as the omniscient overseer. It is important to note that these groupings represent castes, not social classes. Capitalism did not yet exist when this image was made. *The Three Estates* is a static model of hierarchical complementarity, in which membership in estates was divinely ordained, and movement between estates was precluded by law. *The Three Estates* is the earliest example I have found that employs textual labels for each social group— evidence of a remarkable visual continuity across five centuries.

While in exile in the Netherlands in the 1930s, the German graphic designer and council communist Gerd Arntz produced the block print *The Third Reich* [9], a warning about the build-up of Hitler's fascist war machine that circulated primarily in Dutch communist

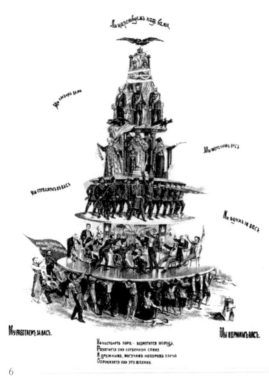

between the workers and the army. Arntz has also tilted the entire structure slightly, suggesting its imminent collapse. In 1936 *The Third Reich* was removed from an exhibition in Amsterdam that was mounted in opposition to the Olympics being held in Berlin, after complaints by the German embassy that it insulted a "friendly head of state."

journals. Using the pictogram style he developed, Arntz depicted German industrialists and Wehrmacht soldiers above industrial workers disseminating resistance pamphlets. Rather than the discrete divisions between classes we see in earlier pyramids, Arntz presents the pyramid as more integrated. For example, the figure of the brown shirt, a precursor to the Nazi SA and the later SS, recruited largely from the disenchanted German working class, is positioned

In contrast to Arntz's high modernist aesthetic, the Italian artist Roberto Ambrosoli's *Anarchy in the Social Pyramid* [10] presents a very different image of social hierarchy in early 1970s Italy. Gone are the physical structures—tiers, platforms, discs—separating social classes. Instead, we see a pyramid composed of a chaotic, though still hierarchical, mass of tangled bodies, each one standing on the head and shoulders of those below. Nixon, Mao, the Pope, and several Italian politicians vie for position

above members of the security forces, professionals, workers, hippies, a Red Brigade militant, a drunkard, a farmer, a woman, and a child. First published in the April 1971 issue of the anarchist magazine *A-rivista Anarchica*, Ambrosoli's pyramid was made during the transition from a rigid state-centric Fordist economy to the flexible labor economy of neoliberal capitalism. It presents society as a "social factory," the Italian Autonomist idea that all forms of social life had been subsumed by capitalist production such that it could no longer be isolated from other social activity. Strangely absent from Ambrosoli's depiction is the centrality of women's labor—just a single woman is represented. This is curious, given that Italian Autonomist feminists at the time had developed critiques of how the capitalist social factory rendered unwaged housework invisible.

A pyramid in English and Zulu from 1970s South Africa [11] also forgoes the use of physical structures to represent the rigid social divisions under the apartheid regime. Caste-like rows of white male social groupings—politicians (including then-Prime Minister P. W. Botha), protestant ministers, land owners, judges, jailers, and security forces—are shown rising above an agitating base of women, men, and children, whose ethnic and racial diversity is depicted in black and white through patterned clothing.

The colonial relationship implicit in the South African pyramid—the whites are descendants of Dutch and English colonizers—is rendered explicit in *Capital Controls You* [12], made for the Utrecht Anarchist Collective in 1977 by Tais Teng, a pseudonym of the artist and science fiction writer, Thijs van Ebbenhorst. Here we see the pyramid of Dutch society resting parasitically on the "third world" in a colonial relationship based on the violent expropriation of resources and labor over centuries, an immense source of capital accumulation. Along with the image of society as a social factory, *Capital Controls You* adds a core-periphery paradigm, popularized during the post-war period of anticolonial struggles, in which the developed, northern, white, wealthy "first world" is at the center, and an under-developed, southern, nonwhite, poor "third world" is at the margins.

PYRAMIDE A RENVERSER

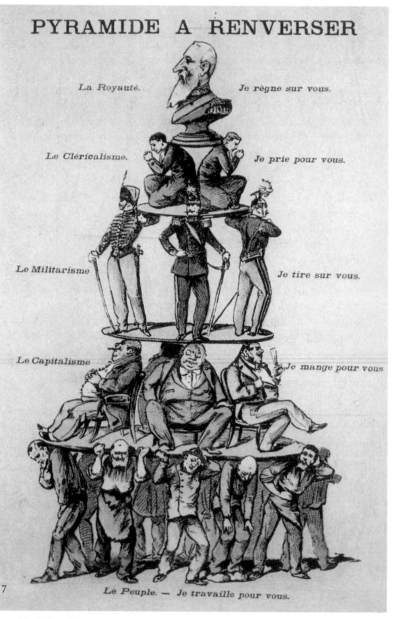

La Royauté. — Je règne sur vous.

Le Cléricalisme. — Je prie pour vous.

Le Militarisme — Je tire sur vous.

Le Capitalisme — Je mange pour vous

Le Peuple. — Je travaille pour vous.

Unlike the Dutch pyramid, the German, Italian, and South African pyramids do not reference capital with textual labels. All of them suggest a notion of class in the figure of a large base of workers, but the emphasis is on the nation-state's *political* power and forms of direct social control. The Dutch pyramid includes these power relations, but it adds an imperialist dimension, globalizing its perspective, and linking it explicitly with capital. But the "third world" is presented *outside* the pyramid, that is, although they are exploited by the capitalist system, the precapitalist social relations of the "third world" are being violently destroyed by ongoing forms primitive accumulation.

In *Capitalism Is a Pyramid Scheme* [13], produced in 2011 by the anarchist collective CrimethInc. for their book *Work*, the image of discretely bounded classes of people and any notion that workers are collectively organizing is gone. This is a freestanding, permanent structure: if those on the bottom walked away the structure would remain standing. And although the entire structure is highly integrated as a whole, it is internally compartmentalized. We see a neoliberal division of labor based on the provision of information, innovation, finance, and services.

CrimethInc. wanted their pyramid, created on the centenary of the IWW's 1911 pyramid, to be "more detailed than the original and updated to account for all the transformations of the past one hundred years." Industrial manufacturing labor has largely been outsourced to cheaper offshore markets. The occupants on each tier also appear to have little if any awareness of, or communication with, those above or below them. We see a few hooded figures (black bloc anarchists?) trashing retail stores, but there are no visible signs of the class solidarity and organized resistance we see in the 1901 and 1911 pyramids. Women and people of color are represented on almost all levels of the pyramid, particularly on the bottom two, where we see the most marginalized low- or no-waged workers, slum-dwellers, homeless, and prisoners—policed by soldiers returned from imperialist wars abroad.

Finally, the Italian, South African, Dutch, and CrimethInc. pyramids, all made

in the 1970s or later, resemble a post-Fordist, neoliberal global capitalism, in which increased privatization and more open markets and trade are seen as giving the private sector more control over the political and economic priorities of the state. It is telling that I have not found any pyramid images made during the period of state-centric Fordist capitalism (roughly 1945 through the late 1970s), a period marked in the U.S. by a strong welfare state, a progressive tax structure, large and politically powerful labor unions, and an abundance of jobs that paid wages sufficient to create demand for mass-produced consumer goods.

INCITE OR EXPLAIN?

The persistence of the pyramid image across great expanses of time and space is hardly surprising given the iconic immediacy with which it communicates structural inequality. It is impossible to know whether it is used because it is so effective, or if it is effective because it is so used. The continued popularity of the 1911 pyramid in the present, particularly since the economic recession of 2008, clearly has to do with the increasing concentration of wealth in the hands of fewer and fewer people, making the present, as some have argued, a new Gilded Age. Even if the 1911 pyramid presents an anachronistic image of capitalist society, it indexes exploitation, hierarchical power relations, and the desire for a redistribution of wealth in the present. The workers on the bottom tier are depicted as a potentially revolutionary force. In contrast, CrimethInc.'s pyramid presents a more pessimistic picture. The social structure is ironclad and there is no sign of organized dissent. But the 2011 pyramid is also more visually complex than the 1911 pyramid. In an attempt to be more realistic, more believable, CrimethInc.'s model of representation-as-mirror—a model all the pyramids use—seeks the greatest possible fidelity between representation and objective reality.

Since the transition to a post-Fordist economy in the 1980s, the image of a networked society has become a common form for depicting the complexity of capitalist social relations and power dynamics. A great example is *The World Government* [14], a 2003 diagram by the

Paris-based art activist collective bureau d'études. Dubbed an "aesthetics of cognitive mapping," its method is to trace various types of associations between institutions and individuals and then plot them in an increasingly complex web of inter-connections. The practical tasks involved in mapping are seen as a way to both reveal and instigate reflection on social totality. Unlike the pyramid, there is no apparent hierarchy, no locus of power, no single agent of history (e.g., the proletariat) that, once removed, would precipitate the collapse of the whole network. Similar to the image of the social factory, the image of a networked society articulates a system that absorbs and organizes all its elements but does not require any specific one of them to function. This visual de-centering of power relations contrasts sharply with the rigid vertical power relations of the pyramid.

On a formal level, like the image of the networked

society, as the pyramid becomes increasingly elaborate—in an attempt to more accurately depict the complexity of contemporary capitalist social relations—it seems to lose its polemical charge. It is no wonder I did not see anyone holding up images of networked society at any Occupy Wall Street protests.

While CrimethInc.'s reuse of the pyramid is an attempt to balance the twin desires of explaining and inciting, of cognitive and affective experience, it also has something to do with maintaining a

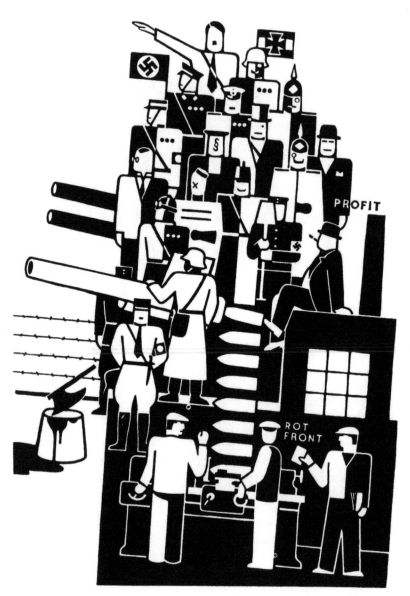

9

visual tradition. CrimethInc.'s pyramid retools a hallowed icon in the inventory of left political imagery. New generations of art activists often appropriate the visual idioms of earlier periods, adapting them to the social conditions and aesthetic sensibilities of the present, as a way to commemorate the image, and radical politics more broadly, as part of a tradition. This symbolic recycling invests old forms with new values, creating an iconic and ideological continuity, pushing against historical amnesia, and reminding contemporary social movement actors that their struggles are rooted in a past that is alive in the present, in part, through imagery.

VISUALIZING THE WHOLE

One thing the capitalist pyramid does really well is to keep the question of the social whole on the table. Think about it. How often do you see imagery that attempts to represent the totality, not of capitalism as an economic system, but of capitalist *society*? Even as a highly reductive cartoon imaginary "view from nowhere," the capitalist pyramid presents a total social structure in which everyone is implicated.

To give this point some sociological weight I want to mention a project I collaborated on that documented five years of visual representations of "crisis" from 2007 through 2012. The study was conducted at the Alternative Press Center, which archives printed editions of three hundred left-leaning publications in English, Spanish, and French. After combing through over six thousand magazines, newspapers, and journals—from high circulation news publications like *The Nation* and *In These Times*, to cultural periodicals like *Adbusters*, to more niche journals like *Historical Materialism* and *Fifth Estate*—we compiled a database of 750 images called the Crisis Image Archive (a project initiated by Daniel Tucker, the archive can be viewed at: http://crisisimagearchives.tumblr.com).

It makes sense that in the wake of the 2008 recession the majority of the imagery in the Crisis Image Archive deals with the effects of the economic collapse on peoples' lives through the issues of austerity, unemployment, debt, housing foreclosure, gentrification, state violence and dispossession. The cause of these effects is more

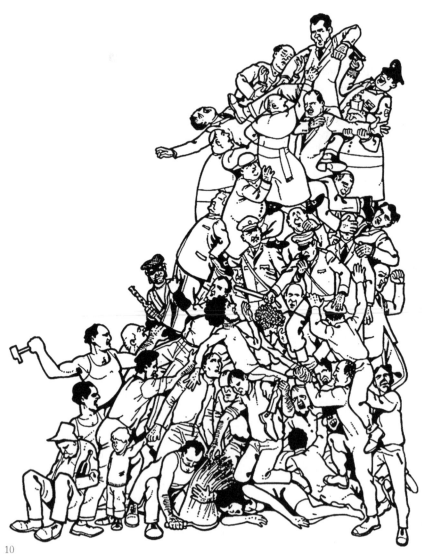

often than not represented by images of greedy white bankers and politicians, the Monopoly man, Uncle Sam, or octopus tentacles. Some of the more abstract representations of crisis use images of graph charts with arrows violently plummeting downward into ruin. What struck me most was the lack of imagery thematizing the idea of a social whole. There are images of the earth and globes that call attention to the ecological effects of anthropogenic climate change—the fact that humans are (asymmetrically) destroying the basis of our shared existence. But the social pyramid compels us to consider *how* we share this whole somewhat differently than an image of a burning globe. The pyramid asks: What is the dominant form of organization that structures social life?

But this is as far as the pyramid goes. Its answer to this question, its answer to the cause of these effects, its answer to overcoming the source of social domination, is to make what is vertical horizontal. Its answer is that hierarchically ordered social relations concentrate power and wealth in the hands of a few who dominate the many. Like the various representations of the "system" in the Crisis Image Archive, capitalism is personified as white men in suits. In the 1911 pyramid they are the fat robber barons of the Gilded Age, with top hats, frock coats, and cigars, whereas in the 2011 pyramid they are health-conscious twenty-first century CEOs. But these are just different tokens of a universally recognizable type. These are the kinds of people one imagines when Naomi Klein, borrowing the words of Utah Phillips, writes: "The earth is not dying, it is being killed, and those who are killing it have names and addresses."

The pyramid poses the question of historical specificity, it calls itself a *capitalist* pyramid, but its answer is transhistorical, something that occurs across all historical configurations of society. The answer to all the pyramids I have presented here, including the 1488 woodcut of the precapitalist German caste system, is to topple hierarchical power relations. This may be why the idea that "the more things change, the more they stay the same" is frequently invoked in online discussions about capitalist pyramids. This comment suggests that although social relations have

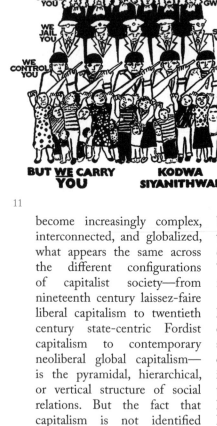

fundamental nature of capitalism as a form of social life is being interpreted, imagined, and represented.

REPRESENTING ABSTRACTION

At this point I want to shift the focus from the rhetorical and representational choices involved in thinking and visualizing capitalism to an analysis that attempts to grasp capitalism's fundamental nature. My hope is that as provisional as this will be, it will help explain why, when viewing pyramid images made centuries apart, it appears that "the more things change, the more they stay the same."

I would suggest that when looking at pyramid images made over a century apart, we mistake seeing the historical continuity of capitalism throughout its various configurations as the historical continuity of hierarchical social relations. By transhistoricizing social domination in social hierarchy as such, the image of capitalist society as a pyramid obfuscates

11

become increasingly complex, interconnected, and globalized, what appears the same across the different configurations of capitalist society—from nineteenth century laissez-faire liberal capitalism to twentieth century state-centric Fordist capitalism to contemporary neoliberal global capitalism— is the pyramidal, hierarchical, or vertical structure of social relations. But the fact that capitalism is not identified entirely with any one of its historical configurations raises questions about how the

the historically specific and abstract character of social domination in capitalism. In order to explain what I mean by abstract domination I will briefly turn to Marx, who provides a very powerful, and I think, still relevant framework for thinking about how abstraction works in capitalist society.

At the core of Marx's analysis of the commodity in *Capital* is the notion that labor in capitalism has a double character. It is both concrete labor, the idea that some form of laboring activity mediates the interaction of humans with nature in all societies; and abstract labor, which does not refer to labor in general, but is a historically specific category signifying that labor in capitalism has a unique social function that is not intrinsic to laboring activity as such. Rather, labor in capitalism serves as a means by which everyday needs—buying a coffee, riding the subway, getting groceries and a haircut, paying for childcare—are acquired. I sell my labor on the market in order to acquire the products and services of others. The labor that is congealed in the things I produce (whether material or immaterial) constitutes a form of social mediation in which different forms of human activity are rendered commensurate as *labor in the abstract*.

The result is a form of social domination that is reconstituted every time someone's labor is purchased (exchanged for a wage), or more commonly, when we consume the goods and services we need each day, without which we could not survive. Although the everyday practices that are mediated by capitalism constitute this form of abstract domination, this mediation has no single source, it is not determined by the actions of a cabal of the 1% who control society. It operates more like the impersonal and diffuse image of power relations we see in *The World Government* diagram of a networked society.

The people in the CrimethInc. pyramid, whose labor is worth very little (temporary, garment factory, and service workers), certainly experience the effects of this domination more acutely than a corporate CEO or financial trader. And there is no question that people of color, blacks in particular, have historically been and continue to be denied access to labor markets or discriminated

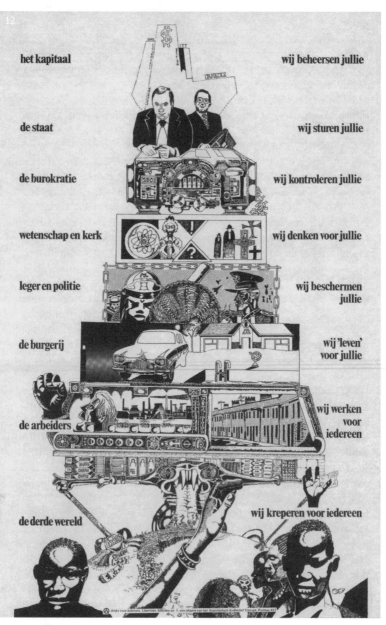

het kapitaal — wij beheersen jullie

de staat — wij sturen jullie

de burokratie — wij kontroleren jullie

wetenschap en kerk — wij denken voor jullie

leger en politie — wij beschermen jullie

de burgerij — wij 'leven' voor jullie

de arbeiders — wij werken voor iedereen

de derde wereld — wij kreperen voor iedereen

against within them. Yet the abstract character of social domination in capitalism subjects everyone to the same imperatives and constraints through a globalized system of exchange that cannot be identified solely with a group of people who do the dominating, e.g., white men in Armani or Kevlar suits, or even social groups such as classes or state institutional actors or agencies. By emphasizing the abstract character of capitalist domination I am not denying the simultaneous existence of very brutal forms of concrete domination, such as forms of slavery or state violence. It is not a question of either concrete *or* abstract domination, but *both*. Concrete forms of social domination such as white supremacy, patriarchy, and heteronormativity are mediated, and gain power, through this socially generalized abstraction.

There are a growing number of people in the U.S. who do not depend solely on the sale of their labor as their means of subsistence, those whose wealth is derived from returns on various financial investments, whether the massive returns of hedge fund managers or the modest returns of working-class pensioners. There are also an increasing number of people who cannot find any employment at all. CrimethInc.'s pyramid represents this growing surplus population through images of heavily policed communities of color and a deeply racist system of mass incarceration. We also see a large group of graduates on the stairs that lead from a classroom, bypassing the low-wage labor tiers, to the professional jobs above. Notice how entry to the upper tiers has been blocked by a chair propped against a door, creating a glut of students in the stairwell. This implies that there is a structural barrier to social mobility and progress through education. But what is the cause of this barrier? It appears that the professional workers put the chair there to protect their scarce jobs and high wages, implying that the crowd of educated, highly indebted, and unemployed students clamoring in the stairwell puts pressure on those with jobs to increase productivity or risk losing those jobs. This interpretation is visually reinforced by the image of a worker, in a sign of fierce competition, pushing another worker out of the window. The cause of this surplus labor

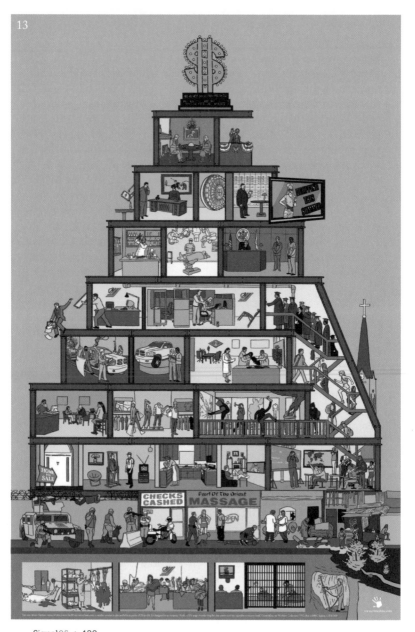

has been identified with the behavior of those in superior social positions, personifying in the contingent decisions of individuals what may have underlying causes in the socially generalized conditions of capitalist exchange.

According to Marx's theory, a large surplus population is an inevitable result of capitalist accumulation. A contradiction arises: on the one hand we must work (sell our labor) in order to survive, while on the other, human labor is increasingly unnecessary. We can see this happening all around us. Technological innovation and automation, which once created time saving devices for industrial labor, now create machines that take the place of people. From the robotization and telecommunication systems that rendered many clerical workers obsolete a decade ago, to computer-generated news articles that are replacing journalists today, human labor in the U.S. is becoming increasingly superfluous from the standpoint of capital.

Through our socially generalized everyday activities of commodity exchange, in which labor in the abstract

is the crucial commodity, we reproduce the cell form of capitalism. Because the vast majority of us are compelled to sell our labor, not by choice, but by necessity, capital can be said to have its own logic: a historical dynamic that reconstitutes its own fundamental condition as an unchanging feature of social life. This dynamic continuously generates what is new— including the possibility of organizing society differently— while regenerating what is the same, and preventing the possibility of a different social life from being realized.

INCONCLUSION

An understanding of capital as an historical dynamic—an engine—offers a powerful way of rethinking the representation-as-mirror model. The cartographic idiom of *The World Government* diagram offers a method and mode of representation that moves beyond the problems of personification and transhistoricization. But what the networked map gains in explanatory effect, it loses in polemic. Perhaps more importantly, just like the pyramids, it relies on two-dimensional representational

The World Government

14

forms, constellations of concrete entities linked by lines. While these lines, which are already an abstraction, indicate a connection or association between two or more entities, they indicate nothing about the nature of that association, the complex ways the association is (abstractly) mediated. In the image of networked society, complexity itself becomes the agent of history. This can lead to the understanding that we live in an overly complex and interdependent social system that cannot be undone—echoing the ideological closure of the post-2008 recession mantra, "too big to fail," which not only refers to the banking system or the economy, but the whole system, the totality of capitalist *society*.

Visual representations may not be able to capture the infinite complexities of social reality, particularly the form of abstract mediation I outlined above. As someone at CrimethInc. said, "representation remains a sort of necessary evil, we don't believe it can present 'the truth,' but we have to use it to intervene in the production of reality all the same." We also have to recognize that we are never in complete control of the wishes and desires images represent, how we speak or write about them, or even our affective responses to them. When images move from our sketchpads, print blocks and screens out into the world, they take on a life of their own.

In a sense, my interest here is less about what social reality is and more about how we *perceive* it, what we *think* or *imagine* it is, and how we go about representing those perceptions and thoughts with visual forms. How do we learn about the world around us by interpreting and making meaning through images? How do we objectify the world we know in the images we make? And how do these ways of knowing inform the ways we make new images—particularly in the realm of social movement politics? The answers to these questions are important because how we think about, imagine, define, and objectify capitalism in images shapes how we struggle to transcend it. ⑤

IMAGES

1 *Human Pyramid* (2011), October 11 Occupy Wall Street Rally, Chicago. Photographer unknown.

2 Robby Herbst, *New Pyramids for the Capitalist System* (2011), performance at the October 11 Occupy Wall Street Rally, Los Angeles. Photograph by Lisa Anne Auerbach.

3 Catherine Jacobi, *Collective Bargaining* (2012), installation of women's handkerchiefs, thread, glue, 40" x 48" x 48", U.S. Source: Packer Schopf Gallery, Chicago.

4 Anetta Mona Chisa and Lucia Tkacova, *After the Order* (2011), marzipan and chocolate layer cake, Austria. Source: Thyssen-Bornemisza Contemporary Art Gallery, Vienna.

5 Artist(s) unknown (attributed to IWW), *Pyramid of Capitalist System* (1911), lithograph, U.S. Source: Nedeljkovich, Brashich and Kuharich. Copyright: International Publishing Co., Cleveland, printed in Spokane, WA.

6 Nikolai Nikolaevich Lokhov, *Pyramid of Autocracy* (1901), Switzerland. Published in Geneva by the Union of Russian Social Democrats.

7 Artist(s) unknown, *Pyramide à Renverser (Pyramid to Topple)* (1885), lithograph, Brussels. Text reads: "The Monarchy, I rule you; The Clergy, I pray for you; The Military, I shoot at you; Capitalism, I eat for you; The People, I work for you." Source: Bruno Margadant, ed., *Hoffnung und Widerstand: Das 20. Jahrhundert im Plakat der internationalen Arbeiter- und Friedensbewegung* (Zurich: Verlag Museum für Gestalung Zürich, 1998), p. 20.

8 Jacob Meydenbach, *Ständeordnung (The Three Estates of the Realm)* (1488), woodcut, Germany. Source: *Prognosticatio* by the German astrologer Johannes Lichtenberger.

9 Gerd Arntz, *The Third Reich* (1934), woodcut.

10 Roberto Ambrosoli, *Anarchy in the Social Pyramid* (1971), Italy. Source: *A-rivista Anarchica*, no. 3, Milan, cover.

11 Artist(s) unknown, *Pyramid* (c. 1970s), South Africa. Source: University of Witwatersrand, Historical Papers Archive, Johannesburg.

12 Tais Teng, *Capital Controls You* (1977), Netherlands, for the Utrecht Anarchist Collective. Source: International Institute of Social History, Amsterdam.

13 Packard Jennings, *Capitalism Is a Pyramid Scheme* (2011), U.S. Source: CrimethInc., *Work* (Salem, OR: Crimethinc., 2011), cover.

14 bureau d'études, *The World Government* (2004), France.

Empty Forms
Occupied Homes

Social Movement Design and the Right to Housing in Neoliberal Spain
Marc Herbst

In discussions with Marta Abad, the designer of the PAH's logo, we found that we shared a concept of what "radical graphic design" might look like—gritty, energetic, and definitely in-your-face. Our imaginary radical design would wear its position on its sleeve and use its realized marriage of form and politics to mix it up, ya know? Punk rock! Bread and roses! No gods, no fuckin' masters.

When we got deeper into discussion, neither of us could actually identify this kind of political design as ongoing practice within social movements today. Truthfully, I was a little embarrassed to have raised the idea and then been unable to verify its actual existence in anything other than the advertising campaigns of athletic-wear companies and sports drinks. I eventually excused myself of this slip into an imaginary projection of "radical" design, and identified it as the cognitive dissonance that exists between the PAH's staid logo and its very real and disruptive political action.

The PAH is a Spanish social movement whose name, La Plataforma de Afectados por la Hipoteca, translates to the Platform for People Affected by Mortgages. The PAH was founded in 2009 in Barcelona as a grassroots organization for common people directly affected by the massive amount of

bankruptcies, foreclosures, and evictions in the wake of the collapse of the Spanish banking system.

What activists created became an active vehicle for social change; the PAH is known for actions that stymie the bank-led, state-supported eviction processes. If necessary, PAH activists occupy banks and blockade apartments to forestall evictions. In fulfilling their promise that if one is with the PAH, you'll never go homeless; they both support and organize the squatting of bank-owned buildings to guarantee the right to housing.

The PAH builds upon Spain's rich history of anarchist organizing and its more recent tradition of creative activism. Yet it distinguishes itself in the fact that the PAH, with all its radicality of occupation, horizontal organizing, and anticapitalist currents, has become a broad and general movement rather than a counter-cultural affair. One of its immediate precursors, with which it shares both similar intent and actual organizers, was the V de Vivienda movement. As you might guess, V for Vivienda (V for Housing) is a take on *V for Vendetta*, playing off the Alan Moore graphic novel long before Occupy flooded the streets with Guy Fawkes masks. The concept of V de Vivienda and its powerful slogan, "You're not going to have a home in your whole fucking life," brought the group to popular attention. Through a series of protests over the course of several months, they coordinated what eventually became a nationwide movement around the constitutionally guaranteed right to housing.

While V de Vivienda gained notoriety in both the mainstream and counter-culture, as a movement it failed to find a mass base of people to carry it along. Ada Colau and Adria Alemany, participants in V de Vivienda who have since become central PAH organizers discuss: "In the case of V de Vivienda, the transformation of . . . young people into social activists was nearly a seamless transition. But were older people affected by the mortgage capable of going beyond their individual cases and getting involved in the political process? Could victims become activists? While V de Vivienda became a media platform for ideas and organization around mortgages, popular movements, and the right to housing, it wasn't able to become a political vehicle for most victims of the crisis.

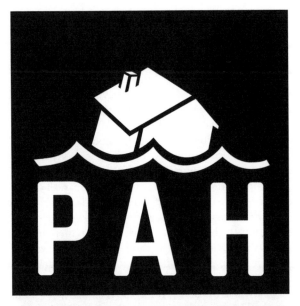

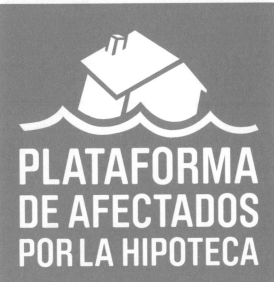

PLATAFORMA
DE AFECTADOS
POR LA HIPOTECA

Basic PAH logotypes designed by Marta Abad.

For me, the PAH logo embodies the ethics and strategies that made the PAH such a useful container for a mass movement to develop. The logo is not just simple, it is almost—but not quite—empty of any specific identity. Here I think of Foucault's ideas around the negatives of having a fixed identity—of having to be associated with, for one reason or another, a group of people you don't have much in common with, or of having a "clearly suspect" identity for the police to identify. The PAH logo allows its members to congregate below it without having to identify as something more than a group of people with a common appreciation of shelter.

In a conversation on the way to a bar, a Spanish design historian described to me the usage of the arch-modernist Helvetica font used in the PAH logo as ironic, almost as though the organization were pretending to be an official institution rather than a radical movement. Abad claims that the choice of Helvetica was not ironic at all—rather it represents what the PAH is: an organization for people who want to get on with their lives.

Notably, activists don PAH T-shirts en masse for protests and other actions. However it's rare to see the same PAH shirts outside of demonstrations. While in much of the world T-shirts are strong signifiers of sub or counter-culture, the PAH design inherently resists this, with members seeing its attribution as much more important politically than socially. This is not to suggest that PAH members do not form an activist community and culture—quite the opposite. It's just that the quality of this community is more open and populist than other activist milieus I've experienced. Since its founding, the PAH has been a multicultural organization. To describe the diversity that I've observed within the Barcelona and Madrid PAHs is to exercise

Clockwise from top left: A flier designed by Leonidas Martin Saura announcing the September 30, 2006, protest for V de Vivienda. The large print reads, "You're not going to have a home in your whole fucking life." Photograph from the September rally. The word bubble coming from the baby in the stroller says, "Mortgages are killing me." An early PAH poster announcing a Barcelona meeting. Earlier posters included more rough images but became simplified for ease of reproduction and general use, as designer Marta Abad says, "It is now in a format so much easier to use by people and you make sure it will not pixilate." Abad based the PAH logo design on this poster produced by the Atelier Populaire image from 1968. On its face, this is an energetic image, though the words suggest a more ambiguous moment: "Drowned Victories—Rising Profits."

NO VAS A TENER UNA CASA EN LA PUTA VIDA.

POR UNA VIVIENDA DIGNA
BOSep **MANIFESTACIÓN**
H PL. CATALUNYA +ACAMPADA

LA HIPOTECA ME MATA

LES CONQUETES NOYEES

ATELIER POPULAIRE C.A.E.N

LES PROFITS MONTENT

MANIFESTACIÓN
PLATAFORMA AFECTADOS POR LAS HIPOTECAS
25 DE ABRIL, 16h

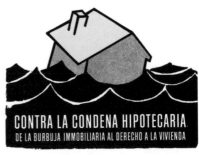

CONTRA LA CONDENA HIPOTECARIA
DE LA BURBUJA IMMOBILIARIA AL DERECHO A LA VIVIENDA

sociology's more floral discourses—"a radical rainbow coalition," "an activist melting pot," "a cross-class, -age, and -race coalition." Early meetings included both formerly well-off and lower-middle class people who had been facing eviction. Its first direct actions were in support of members originally from South America who, unlike PAH members from Europe, had no established care networks to call upon. It was other PAH members they called on for help in facing the truncheons of police and the banks' lawyers.

The initial open form of organization created by the PAH allowed for a multiplication of local and autonomous groups across Spain, which are in turn organized internally through horizontal and vertical structures built around open meetings. These structures have kept the PAH organizationally dynamic and flexible to the changing local conditions within each of its roughly two hundred groups.

The PAH logo design mirrors this flexibility; it has been customized by many of the local PAH groups throughout Spain and beyond. Abad provides a "kit" on the PAH website so that the graphics can be utilized and changed to fit a variety of situations and cities. The logo is primarily in green because it means hope, but it is also available in red because red is a powerful color and black for ease of reproduction. The logo does the job.

Spain, like any country, has a long history of visualizing its people and its politics graphically to marshal and organize its population. Up until 1975, when Generalissimo Francisco Franco died, Spain was a right-wing dictatorship whose politics occupied a space triangulated by the Catholic Opus Dei movement, the fascist

Opposite top: PAH stickers and notices posted on the outside of an occupied Cajamar Bank. Part of the flier reads: "If you are a member of the Cajamar Cooperative Group and it holds your savings, you should know that they are using your money to throw families with children out of their homes in our town." Bottom: The PAH Green Book, *a small, 48-page, freely distributed booklet that explains PAH processes. It also outlines steps for people to fight for their right to housing. The photo on the right is of a house occupied in Barcelona by the PAH as a part of their "Obra Social"—the PAH's collective work to ensure that no one who is a member will become homeless. Translation of text on the left: "We ourselves are responsible for our own cases, but remember that many comrades have been through this experience before and have a lot of information, therefore this counseling is collective. Talk with the people who have already gone through the three steps as they may have useful information for your case. Yes we can!" Design by Marta Abad.*

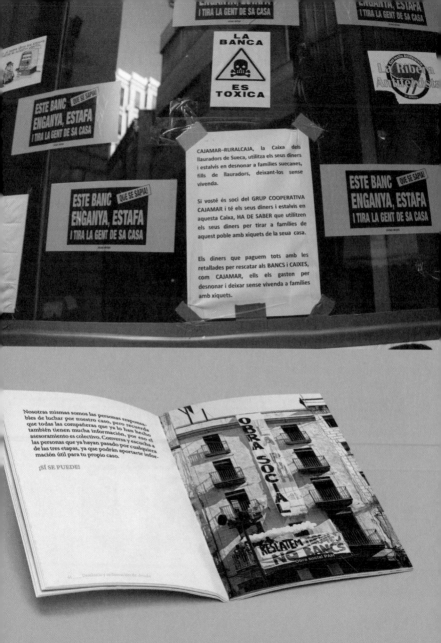

Instrucciones Plantilla: **STOP DESAHUCIOS**

1 Plantilla 1: Sobre una cartulina de 70 x 100cm, marca y recorta la forma octagonal, dejando un margen minimo de 2.5cm del borde.

2 Pon la Plantilla 1 sobre un cartron pluma blanco de 70 x 100cm y 5mm de espesor y pinta con aerosol rojo. Marca los dos puntos de registro. Puedes hacer un degradado añadiendo un rojo mas claro en el medio, si lo deseas.

3 Plantilla 2: Recorta el texto y el logo, teniendo cura de conservar los puentes finos entre las formas.

4 Una vez completamente seco el octagono rojo, pon la Plantilla 2 encima, alineando los dos puntos de registro. Pinta el texto y el logo con un aerosol blanco.

5 Recorta el cartron, conservando un margen blanco de 2.5cm alrededor de lo pintado.

6 Se pueden reforzar los bordes de la pancarta con cinta de embalaje blanca de 5cm de ancho, para evitar que se desconchen con el uso repetido.

PAH graphic toolkit instructions and examples.

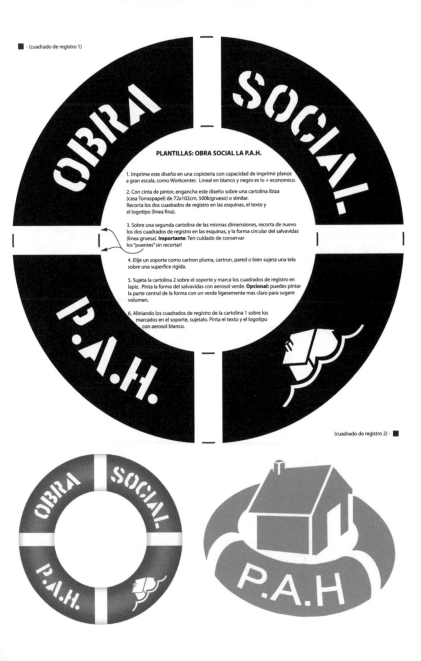

OBRA

SOCIAL.

P.A.H.

PLANTILLAS: OBRA SOCIAL LA P.A.H.

1. Imprime este diseño en una copisteria con capacidad de imprimir planos a gran escala, como Workcenter. Lineal en blanco y negro es lo + economico.

2. Con cinta de pintor, engancha este diseño sobre una cartolina Ibiza (casa Torraspapel) de 72x102cm, 500k(grueso) o similar.
Recorta los dos cuadrados de registro en las esquinas, el texto y el logotipo (linea fina).

3. Sobre una segunda cartolina de las mismas dimensiones, recorta de nuevo los dos cuadrados de registro en las esquinas, y la forma circular del salvavidas (linea gruesa). **Importante**: Ten cuidado de conservar los "puentes" sin recortar!

4. Elije un soporte como cartron pluma, cartron, pared o bien sujeta una tela sobre una superfice rigida.

5. Sujeta la cartolina 2 sobre el soporte y marca los cuadrados de registro en lapiz. Pinta la forma del salvavidas con aerosol verde. **Opcional:** puedes pintar la parte central de la forma con un verde ligeramente mas claro para sugerir volumen.

6. Aliniando los cuadrados de registro de la cartolina 1 sobre los marcados en el soporte, sujetalo. Pinta el texto y el logotipo con aerosol blanco.

(cuadrado de registro 2) -

Falange, and market-oriented technocrats who claimed to govern in a "nonideological" fashion. Though not entirely retrograde, Franco's Spain was a closed society with a heavily centralized conservative and Catholic culture. The regime assassinated political opponents and forced many cultural and political dissidents to leave the country. Yet it was the technocrats who were given credit for bolstering the economy in the so-called Spanish Economic Miracle of the 1960s. Some of these technocrats were covert Marxists and many were university-trained Socialists, the economic growth that they organized eventually became the seedbed for the housing bubble that launched the PAH. To be clear, socialist technocrats working within the fascist government used "socialist tools" to stabilize and grow the country's economy. Upon the ratification of the 1978 constitution, the regime bloodlessly completed a transition to constitutional democracy. Many of the technocrats already working within the government joined the recently legalized opposition that became the Socialist Party. These same two groups, the right oligarchs and their left technocrats re-formed a government post-Franco in what many today characterize as a gentleman's agreement to maintain the status quo (and the buried bodies of the past) in a simulacrum of democracy.

The early period of Spain's democracy was erotically explosive. Emerging from a long sleep, 1970s Spanish graphic design matched the social euphoria with experimentations in form and style, color and movement. Think of the excessive affects of a Pedro Almodóvar film. Meanwhile, Socialist Party graphic design intended to speak for governance affirmative to the entire population rather than just the rich and the church. Political graphic design began to bubble out from modernist formalism and simplistic branding to embrace the sensuous entirety of the living population.

The 1980s saw the Socialists consolidating political power, and the counterculture's vibrant and shimmering design began to be integrated into the representation of official governance. Thus, as the Socialist Party began conforming to neoliberal policies

Opposite top: Early Socialist Party election campaign poster from 1977; design by José Ramón Sánchez. Middle: PAH graphics in use during an escrache. Bottom: "So that you know, this bank cheats, swindles, and throws people out of their homes"; sticker design by Marta Abad.

VOTA PSOE

PSOE

ESTE BANCO ¡QUE SE SEPA!
ENGAÑA, ESTAFA
Y ECHA A LA GENTE DE SU CASA

www.afectadosporlahipoteca.com

through the privatization of public infrastructure and spaces, its graphical face continued its ongoing evolution as expressing energy, creativity, and growth.

The PAH emerged out of the Movement of the Plazas, an anti-austerity movement in the 2000s that shook Spanish society to its core. One result of that movement has been the emerging awareness of the emptiness of Spain's political system—with the Constitution of 1978 being seen as a compact between forces to govern through rhetoric mimicking the voices of both the Left and Right, while maintaining the dominance of the elite. The PAH has been an effective vehicle for this critical awareness, and its cofounder Ada Colau was instrumental in bringing this analysis to national attention. As the organization's national spokesperson, she presented the Spanish Parliament with a petition signed by almost one and a half million Spaniards to, among several things, end the country's punitive bankruptcy laws. The parliament refused to act on the petition.

Thus, the PAH launched a campaign to publicly shame the intransigent politicians. They utilized the escrache protest form developed in Argentina and elsewhere to where activists stage spectacular demonstrations in front of the homes of targeted public

This page and opposite: Photographs of actions and protests taken from the PAH website, http://afectadosporlahipoteca.com

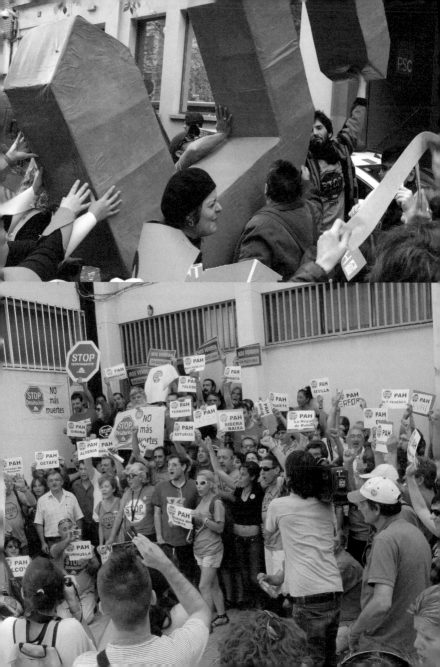

officials. Escraches can be seen as popular politicized hauntings. These hauntings have at least two purposes; to shame wrongdoers and to bring public awareness to the criminals and their crimes.

For the PAH's escrache campaign—which was carried out autonomously throughout Spain, artist and designer Leonidas Martin Saura and the Enmedio Collective developed a second PAH design kit. The kit built upon the minimal aesthetic developed by Abad. Like the original PAH design, simplicity was the main goal, as it needed to be easy to understand and easy to download and print.

The kit contains several image and size formats of red and green circles. These circles were to be held up at protests as cardboard cut-outs. They were printed out as fliers and wheatpasted throughout the city. Storeowners were encouraged to post the circles on their storefronts to show support for the campaign. The circle references the buttons that Spanish parliamentarian's press in order to record their vote within the chamber—a green button says yes, pressing the red button means no. The green circle says, "*Sí se puede* (Yes we can)," the red circle "*Pero no quieren* (But they don't want to)." A statement from the Enmedio design collective said, "As you can see, rather than trying to invent something new, we decided to do just the opposite: to reinforce the existing graphic identity" (Enmedio 2013).

The PAH's graphic design succeeds by being symbiotic with the context it is developed within. The significance of the graphics is constructed by the situations in which they are deployed, so it is this broader PAH organizing that helps define meaning, while at the same time the imagery assists in the success of the movement's work. The design itself doesn't ask much from the viewer—it exists to be put to work, nothing more. But so far, this is enough. ⬤

References

Ada Colau and Adrià Alemany, *Mortgaged Lives: From the Housing Bubble to the Right to Housing* (Leipzig: Aesthetics & Protest, 2014).

Enric Satué, *El diseño gráfico en España: historia de una forma comunicativa nueva* (Madrid: Alianza Editorial, 1997).

Opposite: Escrache graphics designed by Leonidas Martin Saura/Enmedio Collective: "YES WE CAN" side by side with "BUT THEY DON'T WANT TO." Accompanied by associated graphics available from the PAH website.

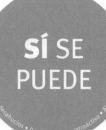

SÍ SE PUEDE

Detener los desahucios • Dación en pago retroactiva • Alquiler social

PERO **NO** QUIEREN

MÁS DE 1000 FAMILIAS REALOJADAS OBRA SOCIAL PAH

VUELVEN A ESPECULAR CON LOS PISOS QUE NOS QUITAN

45

LOTTA CONTINUA

plemento al n. 20
otta Continua
rizz. Trib.
2042 del 15-11-69
Respons.
o Pannella

Fri

DISCS OF THE GUN

MUSIC AND MILITANCY IN POSTWAR ITALY

Josh MacPhee

1

LC 2 A

anche al mi marito

a quando son partito

PROPRIETARIO DELL'OPERA RIPRODOTTA • VIETATA DUPLICAZIONE • PUBBLICA ESECUZIONE RADI

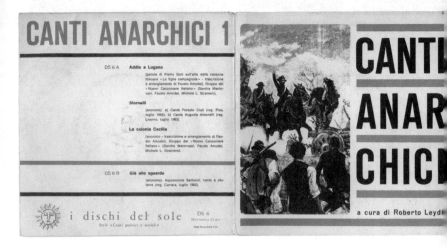

Sometime last year I was helping Silvia Federici and George Caffentzis sort and clean out their apartment and organize their archives. One afternoon Silvia pulled out a stack of 7" records of Italian political folk music. I was immediately captivated. Silvia is Italian, and one of the founders of the Wages for Housework movement—a 1970s feminist organizing strategy arguing that domestic work was a form of unpaid labor central to the functioning of capitalism and the exploitation of the entire working class. When we found this small pile of records, she spoke about the beauty of nineteenth-century Italian anarchist songs and the fun that was had when Wages for Housework recorded their own albums.

Wages for Housework was one of dozens of political groupings that gave structure to the political and social revolt in postwar Italy. Communists, anarchists, feminists, and socialists of all stripes organized in communities and workplaces. The decade of 1968 through 1977 was Italy's "1960s," when workers armed themselves and took over factories, militants kidnapped politicians and industrialists, and housewives went on rent and utility strikes, kicking rent collectors and cops out of their neighborhoods. Revolution was in the air and on the streets, with masses of people taking their lives into their own hands. And these records are a window into the important role culture played in this intense social upheaval. Let's crawl through that window!

Various artists, *Canti Anarchici* 7", I Dischi del Sole, 1963.

I Dischi del Sole ★ *Discs of the Sun*

What *are* these records I've stumbled upon? The first one is encased in a square of thick, white cardstock printed in black and red. The words CANTI/ANAR/CHICI in a tall and bold sans serif are stacked on the right side, each line separated by a bold red line. The left side is filled with a nineteenth-century engraving, dark and hard to read at first, but it resolves into a line of proletarians in the foreground, armed with knives and rifles, marching on a military officer on horseback, sword raised in counterattack. OK, I'm hooked—and I haven't even put the music on yet. The cover opens—it's a miniaturized version of a traditional gatefold LP sleeve—to reveal extensive liner notes explaining the history and context of all four songs on the record. The design is clean, effective, and unobtrusive—it's all very modernist, reminiscent of Bauhaus and Jan Tschichold. Nothing like the record covers of a band like Crass, the standard for anarchist rebelliousness in the Anglo world.

The back cover features a crackling red sun logo and the name of the record label: I Dischi del Sole. The cover mentions "a cura by Roberto Leydi," [curated by . . .] and after some searching, I figured out that Milan-based folklorists and ethnomusicologists Roberto Leydi and Gianni Bosio launched the label in 1962 with the aim of reviving the folk music traditions of Italy. This project had been

simmering for a while: Leydi had actually been an assistant to Alan Lomax when he was doing field recording in Italy in the 1950s, so he was familiar with Folkways Records and the ongoing folk revival in the United States. In 1957 he even wrote a book about the politics of U.S. folk and blues and argued that a similar tradition lived just under the surface of Italian society.

In their first year, I Dischi del Sole produced their first full-length LP, a curated overview of Italian folk songs entitled *Bella Ciao*, but the real core of the project was the release of over twenty 7" recordings, including *Canti della Resistenza Italiana* [Italian Partisan

From left: various artists, *Canti Anarchici 2* 7", I Dischi del Sole, 1963; various artists, *Canti e Inni Socialisti 1* 7", I Dischi del Sole, 1963; various artists, *I Canti del Lavoro 1* 7", I Dischi del Sole, 1963; various artists, *Il Povero Soldato 1* 7", I Dischi del Sole, 1963; various artists, *Canti Comunisti Italiani 1* 7", I Dischi del Sole, 1963.

Songs], *Canti e Inni Socialisti* [Socialist Songs], *Canti del Lavoro* [Work Songs], *Il Povero Soldato* [Soldier's Songs], *Canti Comunisti Italiani* [Italian Communist Songs], *Canzoni dal Carcere* [Prisoner's Songs], and two different *Canti Anarchici* records.

Meanwhile, my turntable starts and the first accordion chords of "Addio a Lugano" [Farewell to Lugano] shine out of the speakers. This is the most popular anarchist song in the history of Italy—although I'm not sure if that's actually saying a lot—originally written by Pietro Gori in the late nineteenth century. Gori had dived

headfirst into the anarchist movement as a youth, being arrested multiple times for protesting and "inciting class hatred." He took to writing poetry, which in turn became song. After writing a song about the anarchist assassination of the French president in 1894, he was arrested and exiled. While awaiting his expulsion in prison in Lugano (a city now in Southern Switzerland), he wrote "Addio a Lugano." The version on this record is poly-vocal and plaintive, simultaneously an ode to his lost country and a statement of determination that these banned anarchists would spread revolution wherever they were forced to go.

Amore Ribelle ★ *Rebel Love*

Who doesn't have a soft spot for one-hundred-twenty-five-year-old insurrectionary Italian anarchist bards? Well, maybe it's just me. I track down two more Gori songs, "Stornelli D'esilio" [Exile Ditties] and "Amore Ribelle," [Rebel Love] on the LP *Canti di Protesta del Popolo Italiano/Canti della Resistenza*. The cover of this record is striking as well, but for a different set of reasons. Rather than austere and modernist, it has a proto-punk sensibility. The red and black are joined by a pulsing yellow, and there is almost no blank space on the surface, no place for the eye to rest. The right side of the bisected cover is a collage, in the background an inverted

stereo VPA 8133

ALBATROS
Folk Music Revival
I DOCUMENTI DELLA NUOVA CANZONE

CANTACRONACHE 4

CANTI
DI PROTESTA
DEL POPOLO
ITALIANO
ITALIAN PROTEST SONGS

CANTI DELLA
RESISTENZA
SONGS OF THE ITALIAN RESISTANCE
cantano
Edmonda Aldini
Fausto Amodei
Margot
Michele L. Straniero

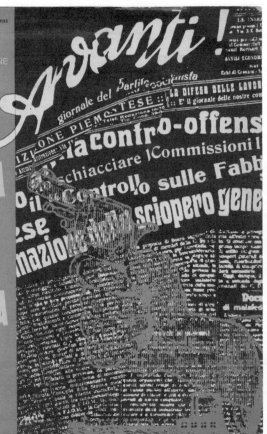

nineteenth-century socialist newspaper with the headline "Avanti!" [Forward!] scorching across the top and spilling over into the left side. Superimposed over the newspaper is a large red fist holding a handgun, with a small factory and fields in the background.

Flipping over the record, the back cover actually has extensive information in both Italian and English. This album was recorded by a Turin-based group of musicians, writers, and intellectuals who coalesced in 1957 and called themselves Cantacronache [which roughly translates to Song Chronicles]. The group developed out of a desire to challenge the conservative bent of the popular culture promoted by state-run radio and music festivals. Looking towards Bertolt Brecht, Hanns Eisler, and Kurt Weill in Germany and the political chanson tradition in France, authors such as Umberto Eco and Italo Calvino wrote new lyrics for traditional popular songs. Musicians in the group, including Michele L. Straniero, Edmonda Aldini, and Fausto Amodei, started recording new versions of traditional folk songs and released a series of 7"s of these recordings from 1958 through the early 1960s. This LP is a collection of these singles. As the back quotes Straniero, these songs were "written for the purpose of modifying the vein of Italian pop music by substituting the wearisome, trite texts with lyrics implying precise involvement and participation in the immediate and more pressing problems and events of daily life."

The record was released by Albatros in their "Folk Music Revival" series. Albatros was a sub-label produced and distributed by the Milan-based Vedette Records, which is in turn owned by the composer Armando Sciascia. I can't find much directly connecting Sciascia to politics, but he must have been committed, since his label not only spawned Albatros, but two other political-folk related sublabels. I Dischi dello Zodiaco released a broad list of Italian folk with a strong collection of Nueva Canción records by Inti-Illimani, Quilapayún, Angel and Isabel Parra, and Daniel Viglietti. Way Out was a third subsidiary, with a much tighter list focused on explicitly political folk, including partisan songs, more anarchist songs, and one of my favorite finds, a recording of a Communist folk concert titled simply—and strangely—*Meeting*.

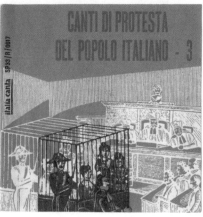

Nuovo Canzoniere Italiano ★ *New Italian Songbook*

So how did all these musicians (Leydi, Amodei, Straniero, etc.) I've been talking about come together? This next 7" offers some clues. The cover is modeled after a matchbook, with a photo of a line of wood matches tucked into a white strip at the bottom that holds the title, *Il Canzoniere Italiano 1: Canti di Protesta del Popolo Italiano* [The Italian Songbook 1: popular Italian protest songs]. It's quite a strange design. The matches have faces drawn on their heads, and appear to be singing. Three matches on the right are painted the colors of the Italian flag—green, white, and red—while the rest are simply red. The red matches on the left have caught fire, threatening to spark the lighting of the entire set. It's from 1964, and this is the first product of the newly formed Nuovo Canzoniere Italiano [New Italian Songbook] movement. NCI formed out of the 1963 merging of the Turin-based Cantacronache group with Roberto Leydi and Gianni Bosio in Milan. The Gruppo del Nuovo Canzoniere Italiano (comprising Edmonda Aldini, Michele L. Straniero, and Fausto Amodei) recorded this one 7" on the small Turin-based CEDI label in 1964, before the NCI's output moved largely to I Dischi del Sole.

As I mentioned above, I Dischi del Sole quickly put out a flood of records capturing the history of Italian popular music, and most of these songs were sung by the stable of artists involved in Nuovo Canzoniere Italiano. I Dischi del Sole also began releasing new songs by these artists and other contemporaries, some on a sub-label called Linea Rosa [Red Line] which focused on contemporary

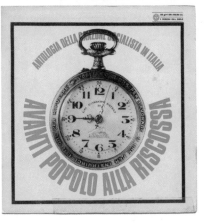
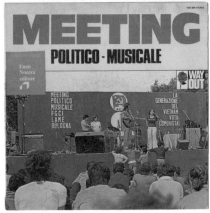

From the left: Gruppo del Nuovo Canzoniere Italiano, *Il Canzoniere Italiano* 7", Cedi, 1964; various artists, *Canti di Protesta del Popolo Italiano 3* 7", Italia Canta, 1961; various artists, *Avanti Popolo alla Riscossa* LP, I Dischi del Sol, 1968; Various artists, *Meeting Politico-Musicale* LP, Way Out, 1975.

political folk and folk rock. From today's vantage point it is hard to imagine this as anything other than pretty marginal stuff, but from 1963 through the early '80s, I Dischi del Sole released over two hundred LPs and 7"s, many going through multiple pressings because of their popularity. Never mind the output of all the Vedette sub-labels discussed above, as well as a dozen more labels.

I Dischi del Sole's output is unique and notable because of its strong visual consistency and eye towards high quality cover design. The covers of most of the early records were designed by Giancarlo Iliprandi. His role here was similar to Ronald Clyne's with Folkways Records, branding the label and the larger musical project with a bold style. Like Clyne, Iliprandi based his design in modernism, using large flat planes of color, strong horizontal lines, reproductions of historical illustrations, and tall sans serif fonts to give the series a near timeless quality. In the mid-1960s the design reins are handed over to Roberto Maderna, who updated the style, adding photographs, montage, and a much broader range of typefaces. One of the most striking things about all these records is how their content is so intensely antiestablishment and antiauthoritarian, yet their aesthetics share so little with what rebellion looked like in the U.S. at the time. No one is going to confuse any of these designs for a Jimi Hendrix or Jefferson Airplane disc. There's no long hair, no

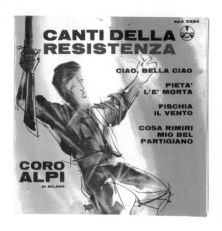

psychedelic lettering, no pot leaves, headbands, or middle fingers. We'll see that by the end of the sixties this will start to change.

While Leydi was aware of the work Lomax and Folkways were doing in the U.S., another important inspiration and point of reference was the Nueva Canción movement in Latin America. In Chile in the 1950s, Violeta Parra had launched a massive effort to collect and preserve thousands of popular songs and folklore, and founded the cultural center Peña de los Parra, which functioned as both a training ground for young musicians as well as a space for political organizing. While 95 percent of I Dischi del Sole's output was Italian, there are a handful of interesting exceptions, including an Italian edition of Barbara Dane's *I Hate the Capitalist System* (originally released on her own U.S. label Paredon—see an interview with Dane in *Signal:03*) and an album by Mexican Nueva Canción musician Judith Reyes (who would later release a record on Paredon in the U.S.).

Bella Ciao ★ Hello Beautiful

More mainstream Italian labels such as Durium, Discofolk, and Fonola also jumped on the bandwagon, releasing a competing stream of politicized folk, in particular different renditions of Italian partisan songs and classics such as "Bella Ciao." In fact, how these traditional songs were sung was an extremely politicized terrain. At the Festival dei Due Mondi in 1964 in Spoleto, Nuovo Canzoniere Italiano stalwart Michele Straniero sang a rendition of the World War I–era folk tune "O Gorizia" in which he included a verse that addressed Italian

army officers as cowards who sent soldiers off to die. This provoked a riot among the audience and a demand by neofascists to include one of their battle hymns. The controversy rocketed Nuovo Canzoniere Italiano and their music into the spotlight, and dramatically increased their popularity amongst youth who previously saw them as out of touch with popular culture.

The youth weren't entirely wrong. By the late '60s kids in Italy, like those all over the world, were interested in experimenting with all kinds of fashion, drugs, and sounds. Meanwhile, around the same time as the festival shit storm, four members of Nuovo Canzoniere Italiano, including Straniero, published a manifesto of sorts about their work—"Le Canzoni della Cattiva Coscienza" (literally "The Songs of Bad Conscience"). The essay was rooted in a Frankfurt School bias against popular music, raising up folk traditions as being more authentic and free of the passivity promoted by mass culture. It became a popular touchstone for Left discussions about music, claiming traditional musics as being more legitimately class conscious. Consciousness aside, one thing that is important to understand about Italy in this time period is that there was an ongoing explosion of working-class militancy, with strikes and factory occupations happening monthly, if not daily, and protests in every major city on the regular. While all of this intellectualizing was going on, another very

embodied part of the appeal of folk music is that workers and students could easily learn the lyrics and tune and sing them on the picket line, or while marching. This was certainly not true of more complicated avant-garde styles or rock music that demanded intense instrumentation.

This tension between the correct political line on music and the desires of youth is a long, red thread that runs through this period. The official left parties of Italy, the PSI (Partito Socialista Italiano) and the PCI (Partito Comunista Italiano), were unique in Europe in that they were both heavily represented within the electoral system and were mass popular parties with large, active working-class bases. They had their own cultures, rooted in a mix of international left history (they each sang their own renditions of "L'Internationale," for instance) and specific Italian touchstones (the role of the left in the struggle against Fascism), and initially shared the NCI's critique of pop culture as a threat to true Italian militancy. In the sixties, both parties released 7" records of speeches backed with ballads and traditional working-class songs ("Bella Ciao," again, was a favorite), but in part because they had electoral pressures to continually build popularity, by the 1970s they began attempting to appeal to broader—and younger—audiences: the PSI released a record with the pop group Equipe 84 and PCI a record with the Stormy Six, a political folk outfit with strong prog rock tendencies. The folk and rock, the old and the new, uncomfortably rubbed up against each other at the Festa del Proletariato Giovanile (Festival of the Proletariat Youth) which was held at Parco Lambro in Milan starting in 1970. Traditional folk, prog rock, jazz, and avant-garde art music all shared the stage. The increasingly strained relationship between the "creative" and the "political" wings of the working-class movement

Clockwise from top left: Rossana Con Il Suo Complesso, *Canto Trionfale della Gioventù Comunista* 7", Disco Estense, 1964; Pino Caruso/Duo Di Piadena, *Basta con la Libertà/ Vogliamo Andare Avanti* 7", Partito Socialista Italiano, n.d.; Various artists, *Parco Lambro—Registrazione dal Vivo della VI Festa del Proletariato Giovanile,* Laboratorio, 1976; Equipe 84/ Enrico Montesano, *15 Giugno '75/Felice Allegria* 7", Partito Socialista Italiano, 1975; Alfredo Pac, *Ricordo di Togliatti* 7", Vedette, n.d.

exploded in 1976 when over four thousand people attended the festival. Direct physical confrontations—including physical assaults and mass looting—between the antiauthoritarian and countercultural Metropolitan Indians and the members of both the PSI/PCI and the more militant organization Lotta Continua (Continuous Struggle). Some have argued that the inability to reconcile these two forms of struggle (a creative/absurdist/nihilistic expression versus a political/ demand-oriented/productivist one) was at the core of the collapse of the movement in 1977 and '78—but that's a bit beyond the purview of this article.

Prendiamoci la Citta ★ *Let's Take Over the City*

In the initial clutch of 7"s that Silvia gave me, there were four records put out by the above mentioned political group Lotta Continua. This ultra-left group had been fellow travelers with

Pino Masi, *12 Dicembre* LP, Circulo Ottobre, 1972. Following page spread, clockwise from top left (all by Pino Masi): *Prendiamoci la Città/Tarantella di Via Tibaldi* 7", *Ballata di Pinelli* 7", Lotta Continua, 1970; *Lotta Continua* 7" side B, Lotta Continua, 1969; *Lotta Continua* 7" side A, Lotta Continua, 1969; *No al Fanfascismo* 7", Lotta Continua, 1972; *Il Popolo Si Fa Giustizia da Sé* 7", Lotta Continua, 1972; *Proletari in Divisa* 7", Lotta Continua, 1971.

intellectuals like Toni Negri, and had been a nucleus for the entire Autonomia upheaval from 1968 to 1977. They were a "workerist" (focus on the worker as the central protagonist of revolutionary struggle) and extraparliamentary Marxist political group that produced a popular newspaper, but musical output—who knew?

The record I'm looking at is in a sleeve printed in a pinkish-red monotone, the cover featuring a pile of kids with fists in the air standing in front of a lineup of militarized police. The kids are holding up a banner that reads "Lotta Continua—Prendiamoci la Città." This is also the title of Lotta Continua's political program as it developed out of the militant worker unrest of 1969, otherwise known as Hot Autumn. Released that year, this is literally a theme song for their campaign, exhorting listeners to move the struggle from the factories and into communities, fighting against rent, evictions, reactionary schools, and prisons. Markings on the record itself reveal that it was released in 1969, a supplement to an issue of the *Lotta Continua* newspaper (year 3, no. 12). Did they press enough records that each copy of the paper came with one? Are we talking tens of thousands of copies? I don't know, but Italy in the 1960s and

'70s did have an interesting law on the books: all newsstands were obligated to carry the full range of newspapers, from all different political perspectives. This meant that papers like *Lotta Continua* weren't simply seen by the "choir," so to speak, but by all that went to down the street to pick up their daily paper.

Expecting to hear the sounds of raw militancy, I'm surprised when I put the record on the turntable. This isn't the Sex Pistols, or even the MC5, this is literally a Bob Dylan tune—harmonica and all—with the words reworked into a call for revolution that would likely make Bob blush. The musician is Pino Masi, originally part of the NCI scene. Not just a musician, Masi was also a writer and painter who collaborated with Pier Paolo Pasolini, Dario Fo, and Julian Beck. He was a militant in the group Potere Operaio (Workers Power) and threw his songs and skills into the worker's struggles of 1968 and 1969. At this time he released singles on I Dischi del Sole with his group Canzoniere Pisano. In 1969, Potere Operaio split, and Masi changed the name of his group to Canzoniere Proletariato and became the musical voice of the new Lotta Continua.

As mentioned before, Lotta Continua weren't the first political party to use music as an organizing tool, the PSI and the PCI setting the stage with releases in the late 1950s and early '60s. Student organizations, unions, women's groups, and the local youth wings of the political parties followed suit, leading to a flood of 7" records, some reproducing partisan songs, some focusing in on worker occupations,

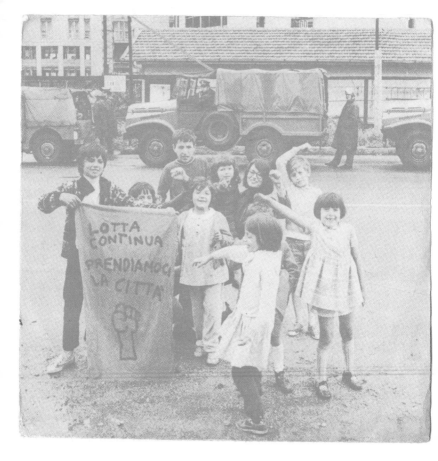

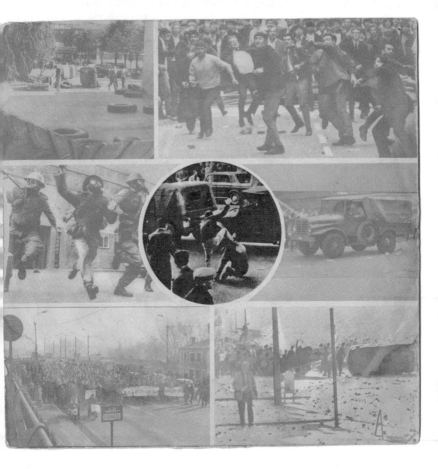

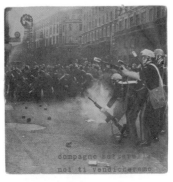

compagno saserella
noi ti vendicheremo

CANTI DI DONNE IN LOTTA

gruppo musicale del comitato per il salario al lavoro domestico di padova

women's rights, solidarity with Palestine or Chile. Lotta Continua was one of the organizations that most actively used music as a propaganda tool. Through their weekly newspaper *Lotta Continua* they distributed over a dozen 7" records between 1969 and 1973. Most were recorded by Masi, the most popular was his "Ballata di Pinelli," a track which narrates the death of Giuseppe Pinelli, a railroad worker and anarchist militant pushed out of the window of a Milan police station in 1969. The tune was picked up by the movement, a standard at demonstrations, and eventually recorded by a half dozen other musicians. The Pinelli incident is also the basis for *Accidental Death of an Anarchist*, a popular play by Italian theatre radical Dario Fo. [Ed. note: Dario Fo's La Comune theatre troupe, as well as other radical theatre groups, played a

meaningful role in this story of postwar Italian music and politics. Unfortunately because of time and space constraints, their contributions could not be explored in this article.]

Alle Sorelle Ritrovate ★ Bring It Back to the Sisters

By the early 1970s, militant feminist groups had begun organizing parallel to other elements of the Autonomia movement. Song quickly became central to their culture, with musical groups evolving out of local organizations. The Wages for Housework collective in Padova had one of the most active groups, Gruppo Musicale del Comitato per il Salario al Lavoro Domestico di Padova. They released two records, the first—*Canti di Donne in Lotta*—independently. The cover is bright pink (in fact, almost all the Italian feminist records I've seen are awash in pink and purple), with simple titling that is minimally designed. The central photograph captures

Clockwise from top left: Gruppo musicale del comitato per il salario al lavoro domestico di Padova, *Canti di Donne in Lotta* LP, self-released, n.d.; Fufi and Yuki, *Canti delle Donne in Lotta n.2—Movimento Femminista Romano* LP, I Dischi dello Zodiaco, 1976; Antonietta Laterza and Nadia Gabi, *Alle Sorelle Ritrovate* LP, Cramps Records, 1975; *Canti di Donne in Lotta* LP, back cover.

the majority of my eyes' attention—it's poorly printed and overly dark, but a woman emerges, on stage and in action. She's bent down and calling out into a microphone while tearing up images of women in popular magazines. She stands in front of a backdrop of painted, lifesize cutouts of a line-up of men: A student, a colonel, a priest, a working-class guy, and a businessman all stand silent, haunting the woman's performance. A flip of the cover finds a giant pink woman's symbol, filling up the entire 12" square. In the center is the clenched fist of protest, but it's clutching money—a 100,000 lire banknote. This is the logo of the Wages for Housework movement.

These women seem like they're having a lot more fun than most of the music I've been listening to by men. There is call and response, group choruses, harmonica interludes, reworkings of classics like "Bandiera Rossa" along with new songs like "Abort the State." And all the lyrics are printed on an inner sleeve so that I could sing along! The music was written by Laura Morato, but the lyrics were a collective endeavor of a half dozen women, including Silvia Federici (who I got the records from) and her fellow activist and theorist Mariarosa Dalla Costa. The record must have ended up being quite popular, because it was repressed by the label I Dischi dello Zodiaco and given much wider distribution. In 1976 and '77, Zodiaco followed up by producing two additional albums of Italian feminist songs: A second record from the Padua group entitled *Amore e Potere* [Love and Power] and a recording of a group of women calling

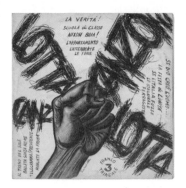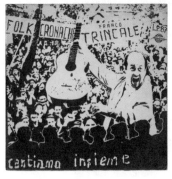

From left: Franco Trincale, *Canzoni di Lotta* LP, self-released, n.d.; *Cantiamo Insieme* LP, Melody, n.d.; *Canzoni in Piazza!* LP, self-released, n.d.; *Il Ragazzo Scomparso A Viareggio—IIIª Disco* 7", Fonola, 1969; *Allende È Vivo* 7", self-released, n.d.

themselves Movimento Femminista Romano. In 1975, the less-folky, more progressive and avant-garde-focused Cramps Records had also released *Alle Sorelle Ritrovate: Canzoni Feministe 1975*, an album produced by Collettivo Femminista Bolognese capturing songs by Antonietta Laterza and Nadia Gabi. It's hard enough in today's environment to imagine a successful album being released of movement songs, never mind four albums produced by different elements within the feminist wing of the movement.

Canzoni di Lotta ★ Songs of Struggle

Is this a punk record? A giant purple fist smashes across the cover, the scrawled words "Canzoni" and "Lotta" flung from it like shrapnel. This is the cover for Franco Trincale's third album, *Canzoni di Lotta*, or Songs of Struggle. Song titles are scribbled between the fist and the words: "Ballad Without a Name," "Telegram to the President," "Executioner Nixon," "The Truth." There is no date on the record, but it is most likely from the early 1970s. There is no producing record label listed anywhere either, but that's because there isn't one. This is part of a series of albums Trincale put out himself, rejecting the conventions of mainstream music production, and instead selling his records "out of the trunk," so to speak. Just like how punk records in the 1980s and '90s would often say, "Pay no more than . . .", the back cover here actually states in large type that you could buy a copy of this record from Trincale for 1,500 lire, about two dollars back in 1975! It also functions like a calling card,

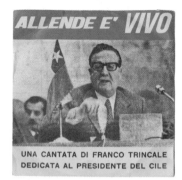

the final line of type reading: "Franco Trincale is Singing at Folk Festivals, Political Gigs, Festivals of Unity" followed by his phone number in Milan.

While Nuovo Canzoniere Italiano and its offshoots were developing a new political folk culture rooted in an ethnographic, academic, and highly ideological understanding of Italian working-class culture, Italy still boasted popular singers rooted in and evolving out of native folk traditions that were still developing and performing. Franco Trincale was a musician trained in the Sicilian storytelling tradition. He started out in the early 1960s writing popular tunes about news events, such as suite of songs chronicling "The Boy Who Disappeared in Viareggio"—the disappearance and murder of twelve-year-old Ermanno Lavorini. In the 1970s, Trincale merged two traditions, Italian storytelling and protest folk, to forge what he called *giornalismo cantato*, or journalism through song. He came from the working class and saw himself as a voice for his people. By telling their stories he denounced injustice, championed their struggles, and called out politicians and capitalists for their greed and corruption.

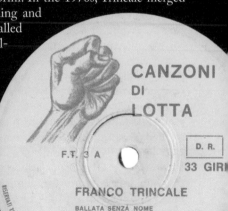

The music has a sing-songy quality, clearly written to be remembered and sung along to. It's simple, Trincale's voice with basic acoustic guitar accompaniment. Listening to the songs between the crackle of the old record, it feels like this music was intended to be enjoyed live, in a group, with people jumping in on the chorus and Trincale talking between verses. And that's what happened—as the working-class struggle became more militant in 1969 (especially during what was dubbed "Hot Autumn"), he began performing live in and outside factories during strikes, crafting songs about workers' struggles and bringing them with him to perform in the next factory, and so on. This is only one of a series of self-released records documenting all these songs that also includes *Cantiamo Insieme* [Let's Sing Together], *Canzoni in Piazza!* [Songs in the Public Square], and *Canzone Nostra* [Our Song].

Un Biglietto del Tram ★ *A Train Ticket*

The cover of Stormy Six's fourth album, *Un Biglietto del Tram* (1975), is captivating yet elusive. A fine-line etching by Piero Leddi is filled with scratchy shapes, some reminiscent of a subway car and riders—others of bicycles, musical instruments, bright lights, and an overwhelming sense of frantic movement. Futurist in feel, a squint gives glimpses of both Tatlin's Monument to the Third International and the illustrations of musicians from 1950s jazz record covers. Sliding out the inner sleeve reveals the lyrics to all the songs, printed over a drawing of factory buildings. This album is a rock opera of sorts, a collection of nine songs about the end of World War II. The first—and most enduring—song is "Stalingrado," about the news of the German defeat at Stalingrad reaching Italy and bolstering the nascent partisan movement against Mussolini.

Founded in Milan in 1966, Stormy Six started out as a pop-rock band (and even toured with the Rolling Stones in 1967), but became involved in the student movement in the early '70s and were introduced to and influenced by the NCI's retrieval of Italian Partisan songs. They quickly morphed into a protest folk act, and then rapidly evolved further into experimental art folk that had as much in common with Pink Floyd as it did the releases of Amodei

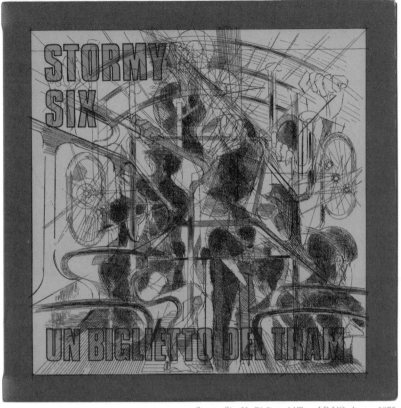

Stormy Six, *Un Biglietto del Tram* LP, L'Orchestra, 1975.

and Straniero. While they rooted their lyrics in the history of the Italian left, their musical compositions looked outside, to the music of Greek antiestablishment composer Mikis Theodorakis, Fado styles from Portugal, and the sounds of Anglo experimental and avant-garde rock. The music on this record has a certain Renaissance fair quality, with mandolins, violins, and flutes flowing in and around rock drumming and guitar chords. It is far more produced than any of the NCI material, with multi-instrumentation and lots of track overdubbing. Listening to it today, with a life's worth of punk and heavy metal in my ears, it's difficult to hear the militancy, but in both content and sound the record articulated the increasing youth turn

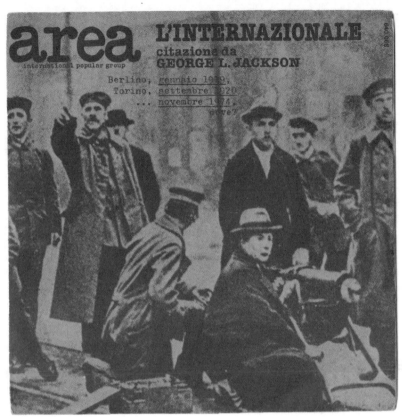

Area, *L'Internazionale* 7", Cramps Records, 1974.

towards extra-parliamentarian politics and attraction to more direct, experimental—and violent—forms engagement. It was immensely popular with students, but heavily criticized by Italian folklorists for being too commercial sounding and abandoning the national project of rebuilding popular tradition.

The album was released independently on the L'Orchestra label. Like Trincale, Stormy Six were interested in finding ways to distribute music outside of traditional commercial and hierarchical models. L'Orchestra was a music cooperative made up of folk, jazz, and avant-garde musicians. The artists managed the label themselves, and used it as a platform for releasing their own music. Continuing

in this vein, in 1978 Stormy Six became part of the RIO (Rock in Opposition) movement, an international prog rock initiative in opposition to the mainstream music industry.

L' Internationale ★ *The International*

Area International Popular Group (more popularly known simply as "Area") was another prog rock band that became massively popular with young militants in the 1970s. Like Stormy Six, they merged a wide-array of musical influences with explicitly leftist lyrics. Their first album in 1973, *Arbeit Macht Frei*, obviously takes its name from the famous inscription above Auschwitz, but the record I'm listening to is their 1974 7" single *L'Internationale*. At first glance the cover isn't that out of line with the aesthetics of I Dischi del Sole—an historical photograph is halftoned in dark brown on a tan background, the band name and title cleanly written at the top. Closer inspection reveals the image is a group of armed militants, part of the "Biennio Rosso" [Two Red Years] in 1919–1920 when workers in Turin and Milan occupied their shop floors and formed factory councils. This experiment in direct worker self-management was influenced far more by anarchists like Errico Malatesta than the Italian Communist Party—making an interesting political point at the time. Small text on the cover says "Berlino, gennaio 1919, Torino, settembre 1920 . . . novembre 1974, dove?," once again bringing the history into the present, connecting the German Spartacist revolt of Rosa Luxemburg to the Biennio Rosso to the then-present, provoking the audience with the question, "where now?"

Sliding the record out of the sleeve, it's adorned with a comic book–style image of Frankenstein, and the record label name—Cramps—in large stylized bubble-letters in the same font as the titling for Kubrick's *A Clockwork Orange*. If the NCI crew felt that political clarity could be found in the local popular musical styles of Italy's past, it's clear that this scene wants to inject liberatory politics into an amalgam of contemporary international pop culture. Putting the record on makes that even clearer—this isn't your parents' "L'Internationale." The tune is recognizable, but rather than a Russian military band running through it, this sounds like

From the left: Coro le Camice Rosse, *Bandiera Rossa/L'Internazionale* 7", Way Out, 1972; Rudi Assuntino, *E Lui Ballava/Stornelli Presidenziali* 7", Linea Rossa, 1967; Franca Rame, *Io Ci Avevo una Nonna Pazza/I Chiaccheroni* 7", Fonit Cetra, 1980; Domenico Modugno/Arnoldo Foà, *L'Anniversario/Cosa ne Pensa del Divorzio* 7", Partito Socialista Italiano, 1974; Movimento Studentesco Milanese, *Inno di al Fatah (Canti della Resistenza Palestinese)* 7", Edizioni Movimento Studentesco, n.d.

the Grateful Dead playing "The Star-Spangled Banner" during the seventh inning of a Communist baseball game. The b-side falls even farther from the Italian folk tree: a song dedicated to U.S. political prisoner and Black Panther George Jackson—free-jazz scratching and space-rock noises undulate under a modulated voice reading a memorial text to Jackson, murdered in prison.

The Stylus Returns to Its Cradle

Nuovo Canzoniere Italiano reject popular culture as a capitalist imposition. Instead they look backward—or sideways—to an innate rebellion of the Italian people that exists just below the surface, always present yet repressed by current social conditions. While this approach is extremely effective at both articulating a rich history of popular resistance and illuminating contemporary oppression, it doesn't always acknowledge that people are always in motion, and that a national past can intuit a path forward, but not actually walk it. Many NCI songs became quite popular in the movement, but it is clear from the examples of Stormy Six and Area that young people also began experimenting with their own musical forms. Feeling a provincialism in the dogged attachment to regional folk arrangements, they refused an inward looking and strict connection to Italian influences. Starting in the folk idiom, they not only quickly

digested and reinterpreted a far-ranging set of other inspirations, but used the interplay between musical styles and historical content in their lyrics to critique the implicit—if well-hidden—conservatism in the older generation.

The relationship between culture and social movements is always a complicated one, and no more so than in the realm of music, which tends to be so much more clearly connected to commercial popular culture than other art forms. Many ascribe avant-garde qualities to art, arguing that its primary role is to presage future worlds—to provide hope and direction to social struggles. Others profess its general irrelevance, for them art is but a field of bourgeois fantasy for those playing at revolution. I would argue that more often than not culture plays both of these roles, and others. It pulls and prods people forward in new ways and orientations while also getting swept up in broader battles, becoming a small part of the long, thrashing body of a mass movement.

Politicized music in Italy in the 1960s and '70s is a great example of this overlap and dichotomy. First, music overlapped with political struggle in Italy in the 1960s in multiple ways. The above records highlight some of these crossroads:

(a) Starting in the late 1950s, a concerted ethnomusicology project was developed (in large part by Roberto Leydi) to research and share the history of people's music in Italy, including worker's, prisoner's, political, partisan, and regional songs. This project was explicitly leftist, and an attempt to catalog people's history and hone

From the left: Michele L. Straniero, *Preghiera del Marine/La Révolution* 7", Linea Rossa, 1967; Canzoniere delle Lame, *E la Lega la Crescerà* 7", CGIL, 1973; Franco Trincale, *Il Ragazzo Scomparso a Viareggio 3* 7", Fonola, 1969; Coop. "La Taba", *Uscire dalla Notte—Canzoni di Lotta del Paese Valenziano* LP, Edizioni di Cultura Popolare, 1976; Various artists, *Canti Partigiani* LP, I Dischi dello Zodiaco, 1972.

it into a tool for future struggle. It also was an attempt to legitimize folk traditions in a context where dominant popular and academic voices rejected these as unworthy of study or focus;

(b) Popular storytelling and theatre traditions were swept up into the worker's mobilizations, so both traveling bards and community theatre projects reoriented towards political struggle (Dario Fo was central to this movement realignment of community performance groups); and

(c) Mass culture attempted to grapple with the political upheavals of the period in varied ways. From above, capitalists tried to figure out how to capitalize on both the explosive popularity of folk music and the increasing desire amongst youth for access to the rebellious rock music culture exploding in other parts of Europe. From below, young people wanted to push the boundaries of folk and pop music, using avant-garde forms to express growing political militancy and uncertainty.

Music in Italy—like the working class—was in struggle, traces of it captured on vinyl, but its core expression was embodied, evolving, and defined by the moment. I've come to love these recordings, their promise of insight into near revolutionary social upheaval, and I've done my best to sort and make sense of them, but I admit I might not have the tools to fully interpret them. They

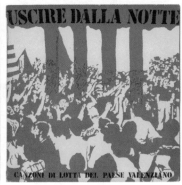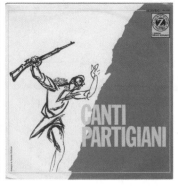

can't show me rows and rows of chemical or metal workers with makeshift drums strapped to their chests banging out polyphonic rebellion bricolaged out of eighteenth-century folk songs, Italian pop culture, and Western rock music—but I know this happened. Similarly, they can't explain what it felt like to be in a neighborhood on rent and utility strike, all of the women and children banging pots and pans—singing songs while kicking out the rent collectors. And maybe most importantly, the use of the objects themselves is difficult to pin down. Who bought these records? Where? Did workers or students have a stack of I Dischi del Sole albums by the home stereo, listening to Sardinian fisherman singing communist songs instead of succumbing to the boredom of watching cop shows after dinner? Or were these records the purview of the Free Radio movement, with DJs on pirate stations such as Onde Rosse and Radio Alice playing tracks between Rolling Stones tunes and interviews with striking Fiat workers? I haven't been able to figure this out yet.

Nevertheless, we have all these amazing recordings and album covers to explore and listen to. They are evidence of a vibrant culture where record production was more than simply the creation of commodities, but a politicized attempt at documenting, participating in, and advancing protest in Italy. These objects bridge the folklorists desire to unearth a true resistant heritage and the militant youth project of experimentation and style as a revolutionary end in and of itself. The purist folk-documentation and the most out-there prog rock noodling are now both flat, round circles of black vinyl left for us to try to interpret. And this feels refreshing in a context where political

discussion around music mostly transpires on social media, and centers around hyped up mass market celebrities calling for tweaks in the system while wrapping themselves in the aesthetics of revolution. It's hard to not be nostalgic for a time when people in the streets would never even think of looking to ruling-class, brand name personalities, no matter how well-meaning, for political direction or even inspiration. Instead they were composing their own songs directly connected to the history of antifascist organizing, the Russian Revolution, anarchist insurrection, and contemporary worker, student, and community mobilization. And this brings us to a tautology: are we busy talking about rock stars because there is no movement, or is their no movement because we're too busy talking about rock stars? **Ⓢ**

There is unfortunately very little in English about music and politics in Italy in the postwar period. These are the resources I found:

Pietro Di Paola, "Popular Songs, Social Struggles and Conflictual Identities in Mestre-Marghera (1970s–1980s)," in *Radical Cultures and Local Identities* (Newcastle upon Tyne: Cambridge Scholars Publishing, 2010).

Franco Fabbri, "Five Easy Pieces: Forty Years of Music and Politics in Italy, from B(ella ciao) to B(erlusconi)," a paper presented at the Music and Politics Symposium, International Centre for Music Studies, University of Newcastle, 2006.

Umberto Fiori, "Rock Music and Politics in Italy," in *Popular Music* 4 (1984): 261–277.

Lotta Continua, *Take Over the City: Community Struggles in Italy* (London: Rising Free, 1974).

Robert Lumley, *States of Emergency: Cultures of Revolt in Italy from 1968 to 1978* (London: Verso Books, 1990).

Red Notes, ed., *Italy 1977–8: Living with an Earthquake* (London: Red Notes, 1978).

Various artists, *Italy, Avanti Popolo! Forward, People!* LP, edited and collected by Sandro Portelli, Paredon Records, 1976.

Photograph: Tano D'Amico, *Sciopero generale [General Strike]*, Turin, 1972.

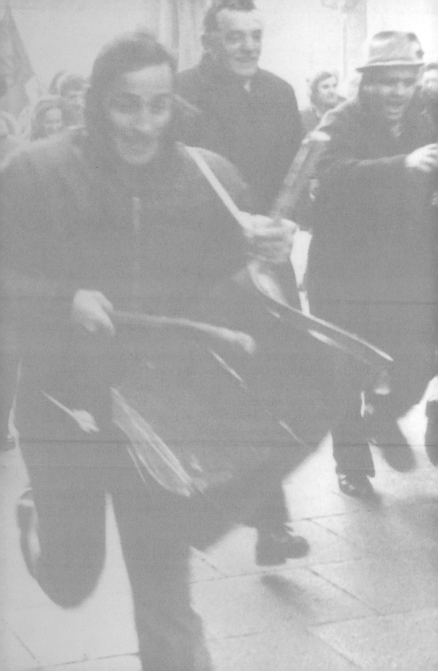

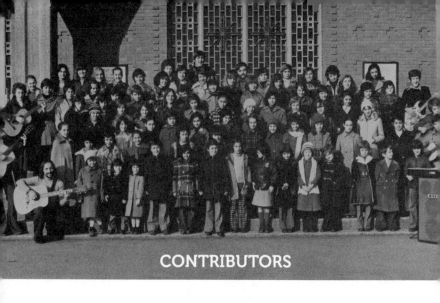

CONTRIBUTORS

Alec Dunn is an illustrator, a printer, and a nurse living in Portland, OR. He is a member of the Justseeds Artists' Cooperative.

Marc Herbst is a co-editor of the *Journal of Aesthetics & Protest* and a PhD candidate at Goldsmiths University. His current research looks at the intersection of the practices of making a livable life (through such social movements as the PAH) and abstract things that such social movements may encounter (like good and bad design, ideas, tables, soda bottles). He is interested in how we, as people, may design ideas that help provide space for a livable life in the time of climate change.

Josh MacPhee is one of the founders of Interference Archive, organizes the Celebrate People's History Poster Series, and is a member of the Justseeds Artists' Cooperative.

Georgia Phillips-Amos attended Utrecht University and works at New Directions. She lives in Brooklyn.

Eric Triantafillou is an artist and writer who lives in Chicago.

"Dunn and MacPhee do an impressive job of conveying not only what is new and relevant in political art, but also its history and its presence in the everyday."

—*Political Media Review*

PM Press was founded at the end
of 2007 by a small collection of
folks with decades of publishing,
media, and organizing experience.
PM Press co-conspirators have
published and distributed hun-
dreds of books, pamphlets, CDs,
and DVDs. Members of PM have founded enduring book
fairs, spearheaded victorious tenant organizing campaigns,
and worked closely with bookstores, academic conferences,
and even rock bands to deliver political and challenging ideas
to all walks of life. We're old enough to know what we're do-
ing and young enough to know what's at stake.

We seek to create radical and stimulating fiction and non-fic-
tion books, pamphlets, T-shirts, visual and audio materials to
entertain, educate, and inspire you. We aim to distribute these
through every available channel with every available technol-
ogy—whether that means you are seeing anarchist classics at
our bookfair stalls; reading our latest vegan cookbook at the
café; downloading geeky fiction e-books; or digging new mu-
sic and timely videos from our website.

PM Press is always on the lookout for talented and skilled vol-
unteers, artists, activists and writers to work with. If you have
a great idea for a project or can contribute in some way, please
get in touch.

PM PRESS
PO Box 23912
Oakland CA 94623
510-658-3906
www.pmpress.org